BLANK COMIC BOOK

DRAW YOUR OWN MANGA!

TUTTLE Publishing

Tokyo | Rutland, Vermont | Singapore

HOW TO USE THIS BOOK

The panels and templates are already laid out for you . . . so are you ready to create your own comics, make your own manga?

A quick comic or a longer story playing out over many pages or volumes? We've got you covered! Fill in the blanks to tell your story as only you can!

Start with the basics and build your world from there: character creation, poses and panels—and don't forget the speech balloons.

Remember there are no rules. No training or classes are required. Artists of all levels can create memorable characters and dynamic, page-turning stories. All you need is a free hand and a free imagination.

Fill in the frames as your story emerges before your eyes. Let your characters and your creativity soar!

Cover Template

Page Template

CREATING CHARACTERS

Do you think pro artists just sit down and dash off cool, compelling characters? They follow a process, the steps and stages needed to get from an idea to a sketch to a finished drawing.

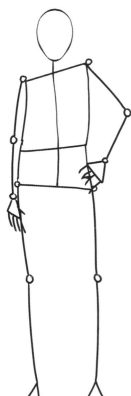

STEP 1

Basic Outline

Create a blueprint, a basic outline. The figure is sketched out using simple lines.

STEP 2

Rough Draft

A person is emerging! The figure is filled in using rough shapes.

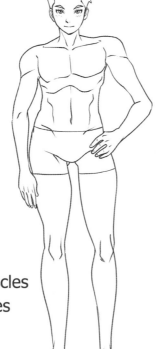

STEP 3

Fleshing Out

Features are added, an expression and hair. Muscles emerge as the body takes on shape and contour.

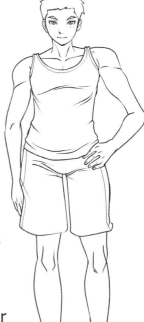

STEP 4

Finishing Touches

The final details. Give him some clothes and add wrinkles. Make your final adjustments.

FOUR STEPS TO A FANTASTIC FURRY

What's your favorite animal? Blend it with some human traits to create a funny and fabulous furry. The same four steps apply.

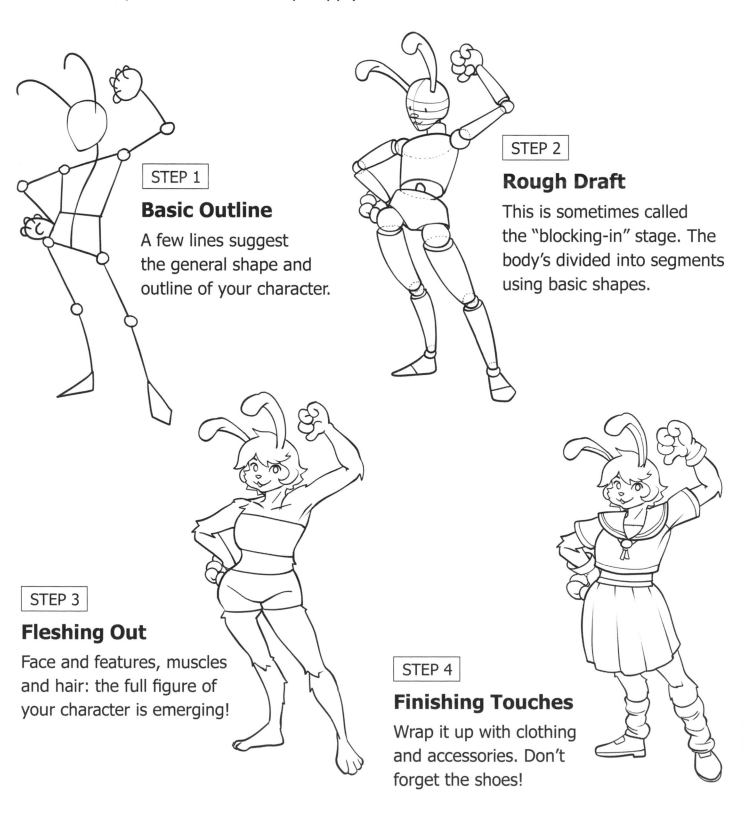

STEP 1

Basic Outline

A few lines suggest the general shape and outline of your character.

STEP 2

Rough Draft

This is sometimes called the "blocking-in" stage. The body's divided into segments using basic shapes.

STEP 3

Fleshing Out

Face and features, muscles and hair: the full figure of your character is emerging!

STEP 4

Finishing Touches

Wrap it up with clothing and accessories. Don't forget the shoes!

POWERFUL POSES

Set your characters in motion. Mix it up. Show their many different sides. Powerful poses make for exciting stories and draw your readers in.

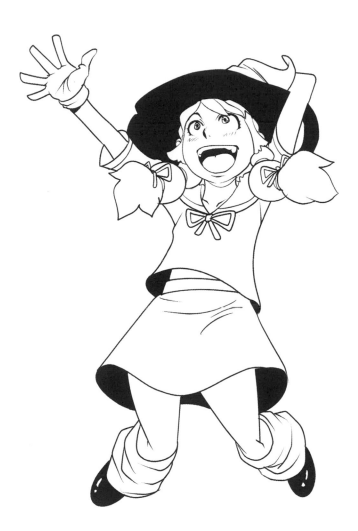

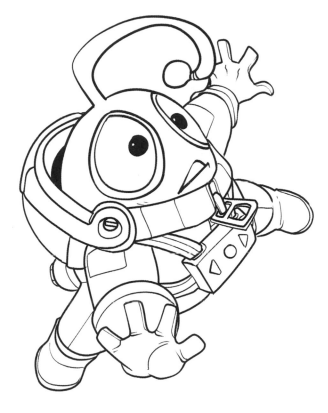

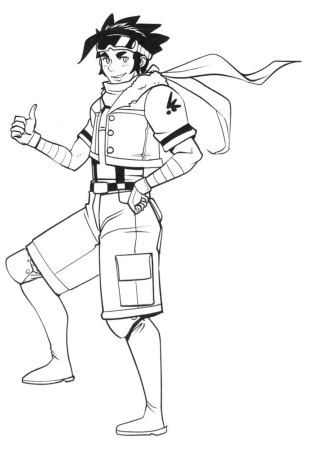

PRO TIPS

Start simple: divide the pose into its basic shapes and segments.

Some artists stand in the mirror to find the perfect pose.

THE PRACTICE PAD: MONSTER MASH-UP

Now it's time to draw your way through the four stages. Sketch the basic shape, then add curve and contour. Before you know it, a muscled monster appears in a powerful pose.

Basic Outline

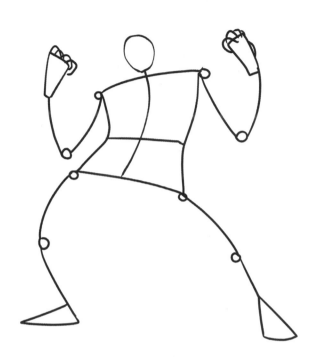

Rough Draft

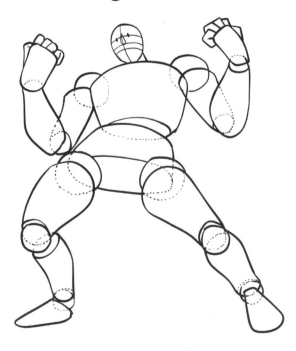

Fleshing Out

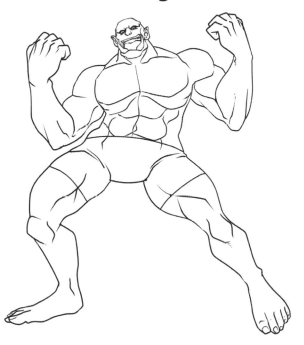

Finishing Touches

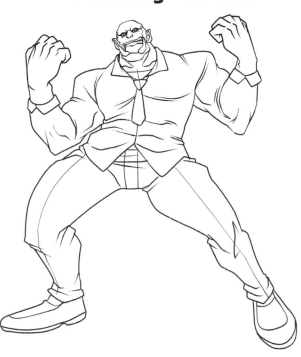

FLEXIBLE SPEECH AND THOUGHT BALLOONS

Here are some common balloons and text boxes. Cut them out, then place and trace them. Or design your own. Create the shape that's needed to fit your characters' words. Just make sure they read left to right, top to bottom.

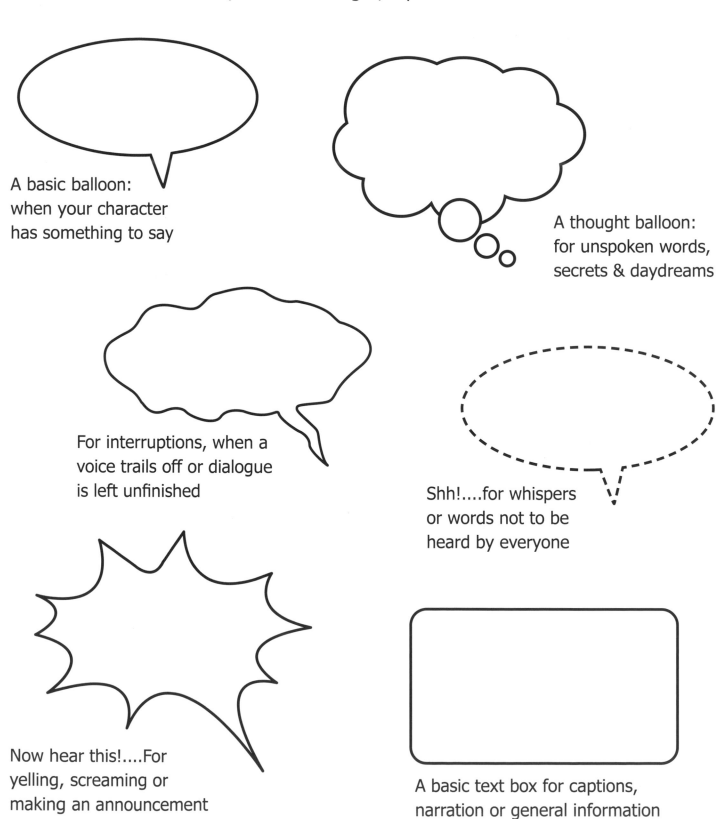

A basic balloon: when your character has something to say

A thought balloon: for unspoken words, secrets & daydreams

For interruptions, when a voice trails off or dialogue is left unfinished

Shh!....for whispers or words not to be heard by everyone

Now hear this!....For yelling, screaming or making an announcement

A basic text box for captions, narration or general information

ANGLES & PERSPECTIVES

How are you going to tell your story? Every panel can't give the same view of the action. Like your character's poses, mix it up. This three-part progression is one way to do it

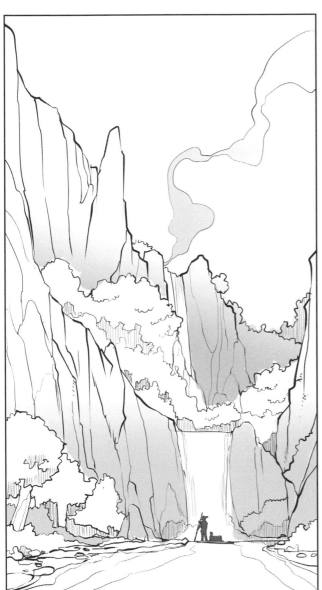

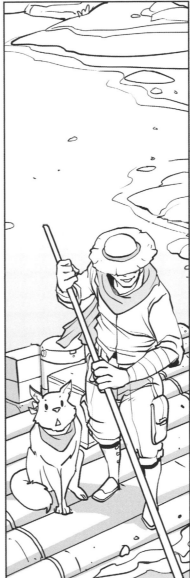

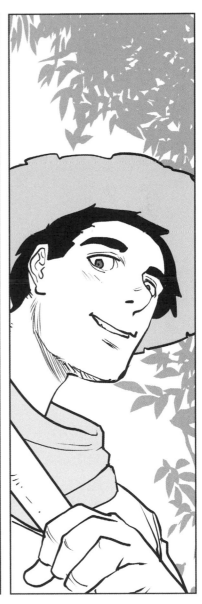

ESTABLISH THE SCENE
A wide-angle perspective helps to set the scene. Where are we and what's going on? This angle helps make that clear.

ZOOM IN
This is sometimes called a medium shot. It draws your reader in while still keeping a little distance.

CLOSE-UP
In your face! For intense or emotional scenes or when you want to draw your reader directly into the action.

MAKE YOUR OWN MANGA!

The same steps apply. Simple lines and basic shapes add up to compelling characters. Start simple, adding details as you go. Your story's taking shape in front of your eyes!

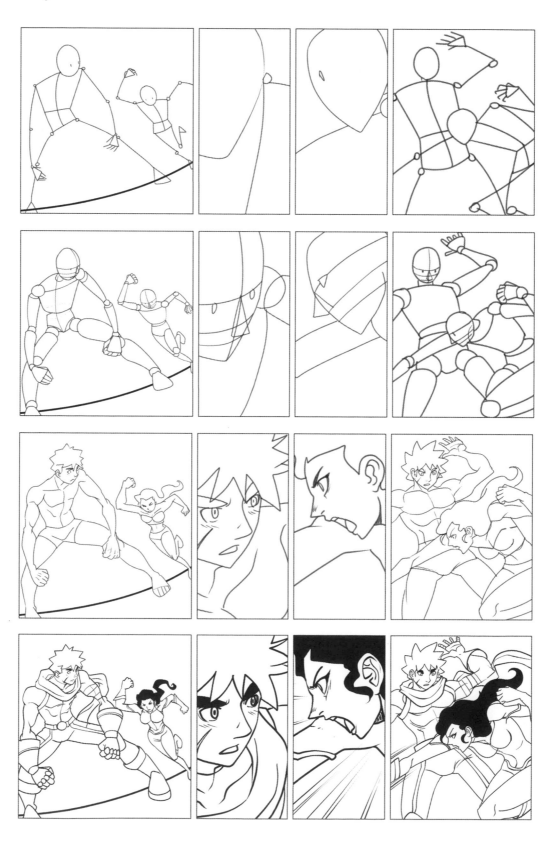

Design Your Own Cover

Design Your Own Cover

Design Your Own Cover

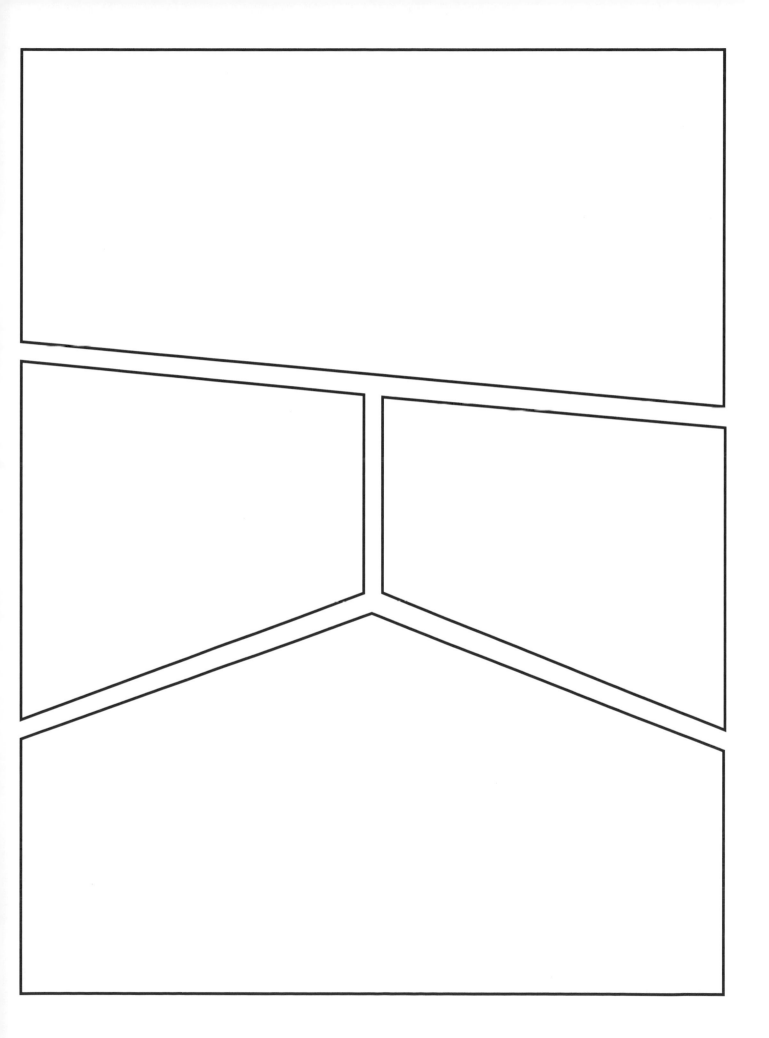

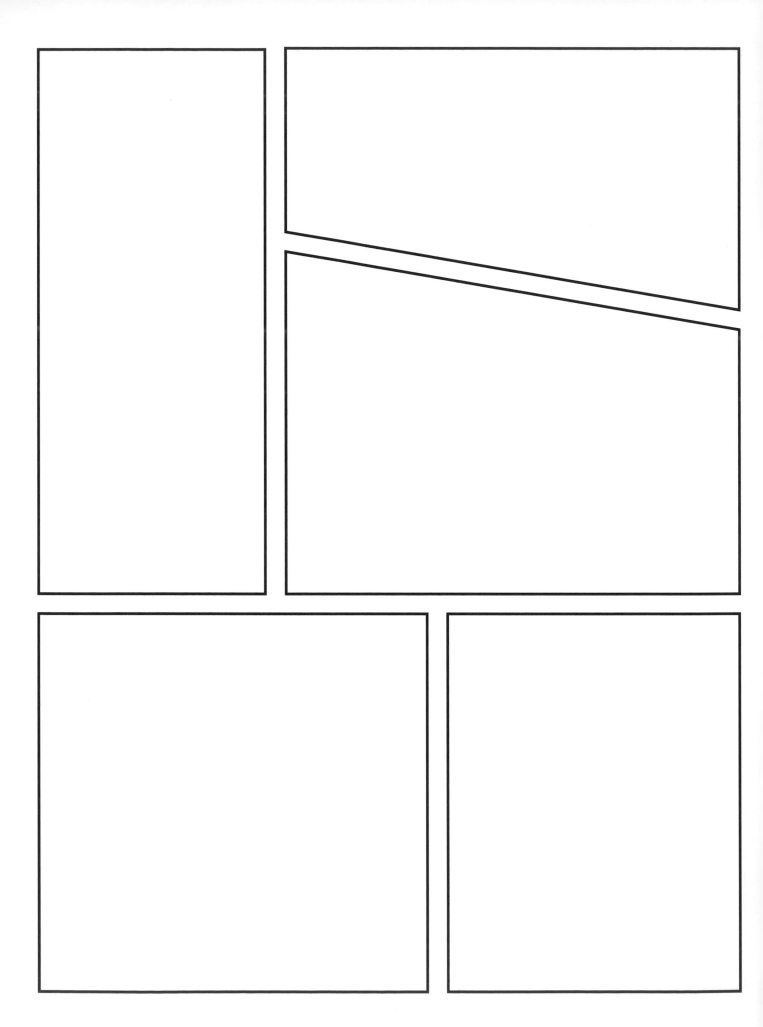

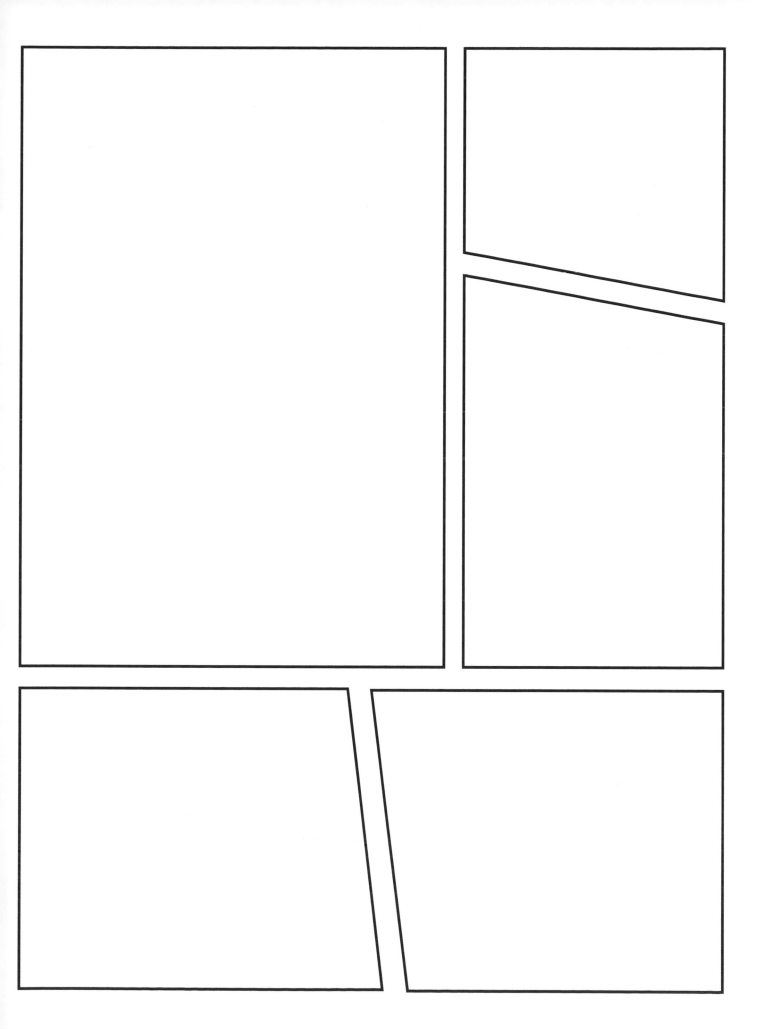

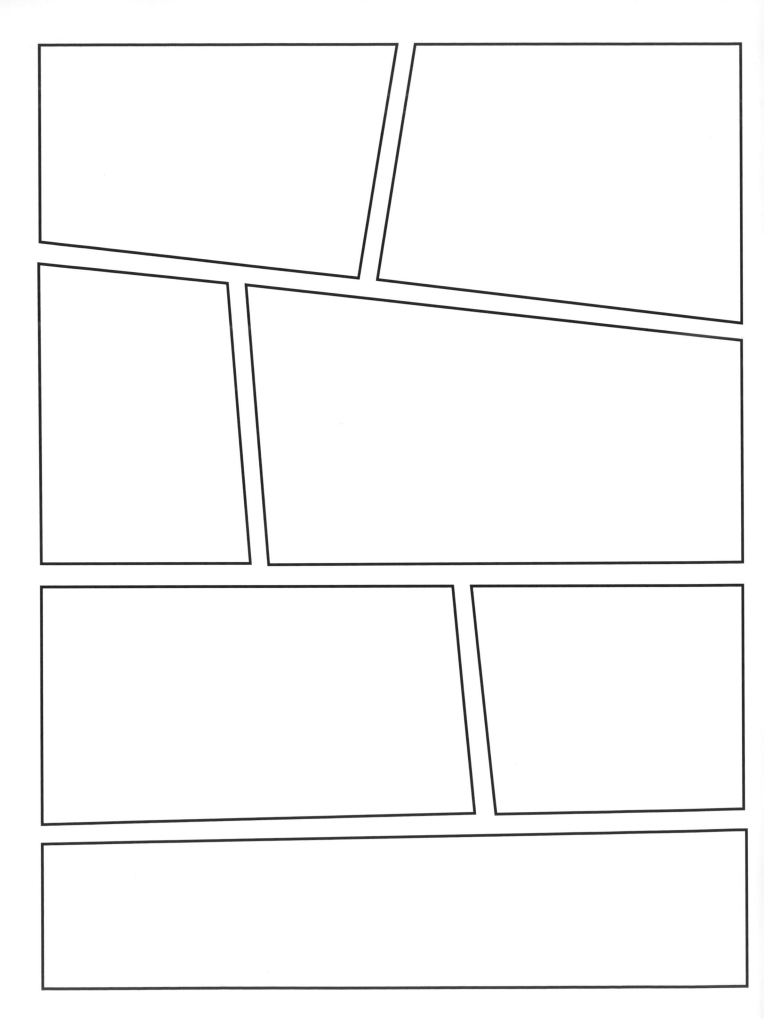

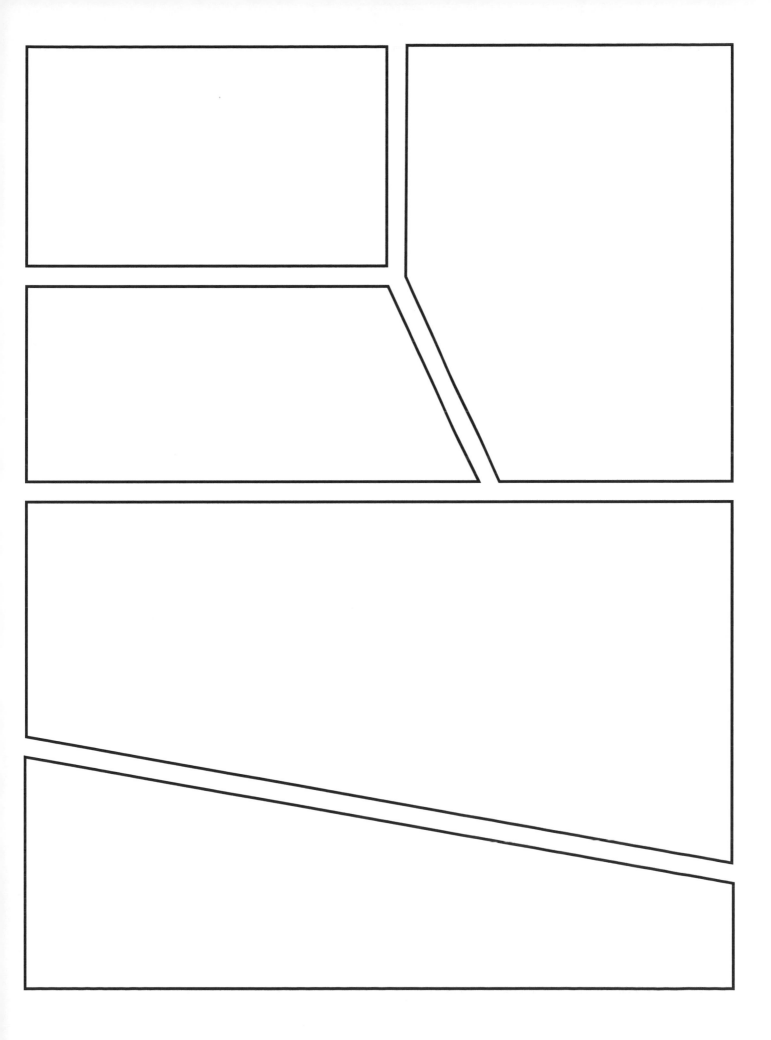

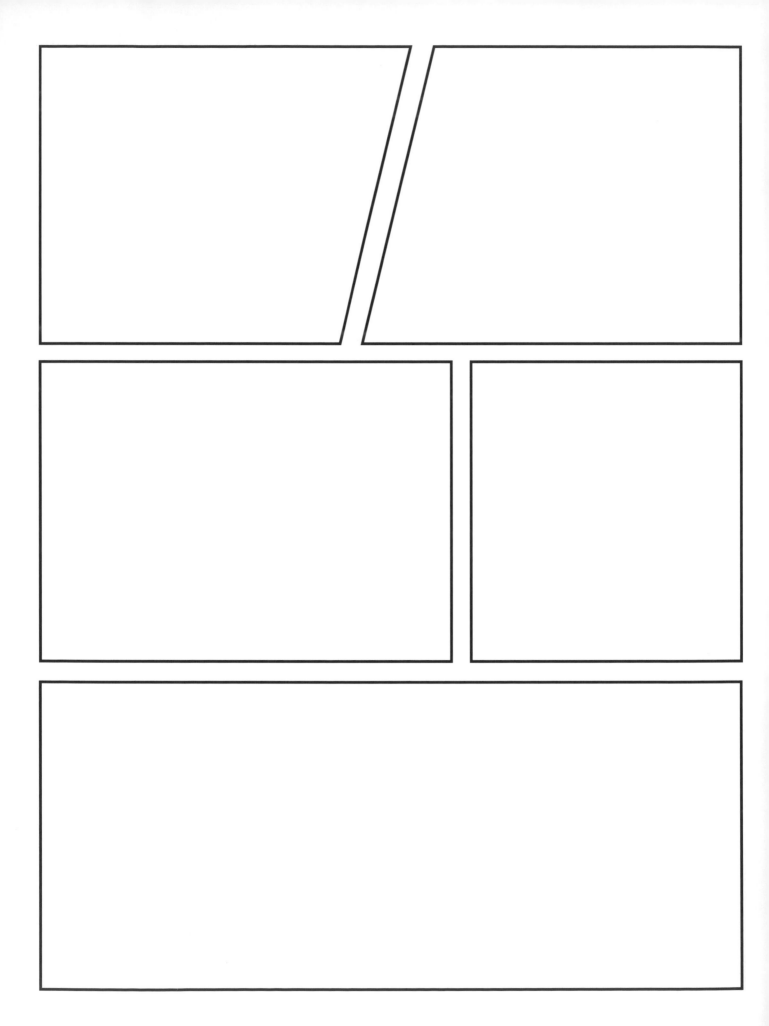

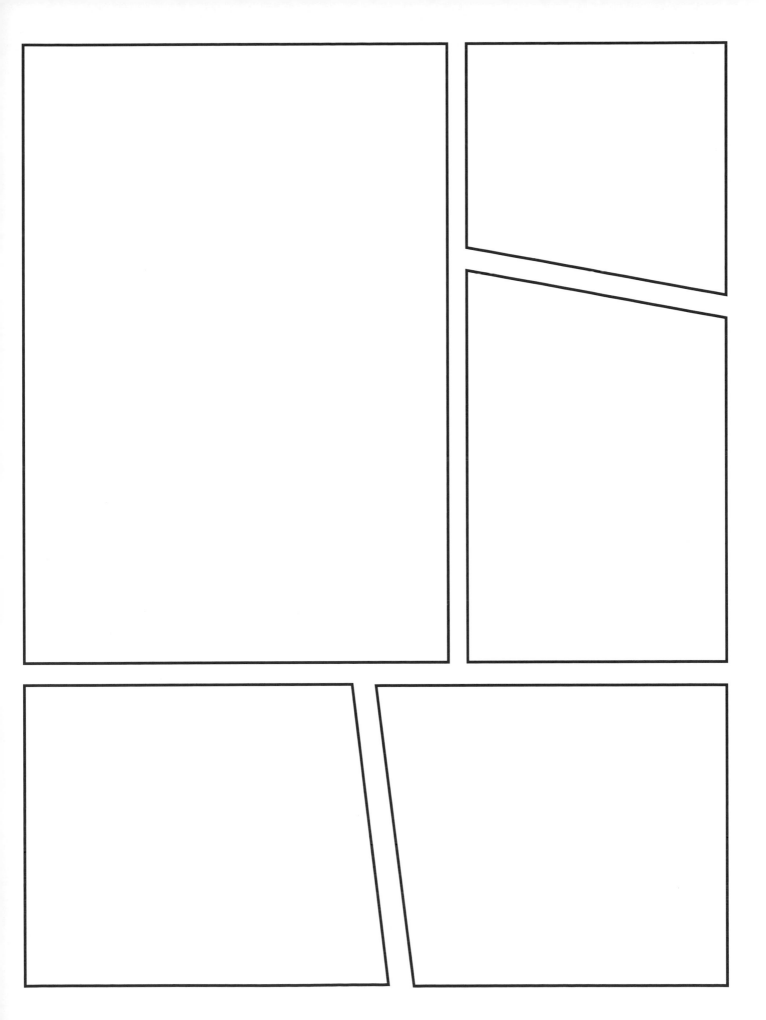

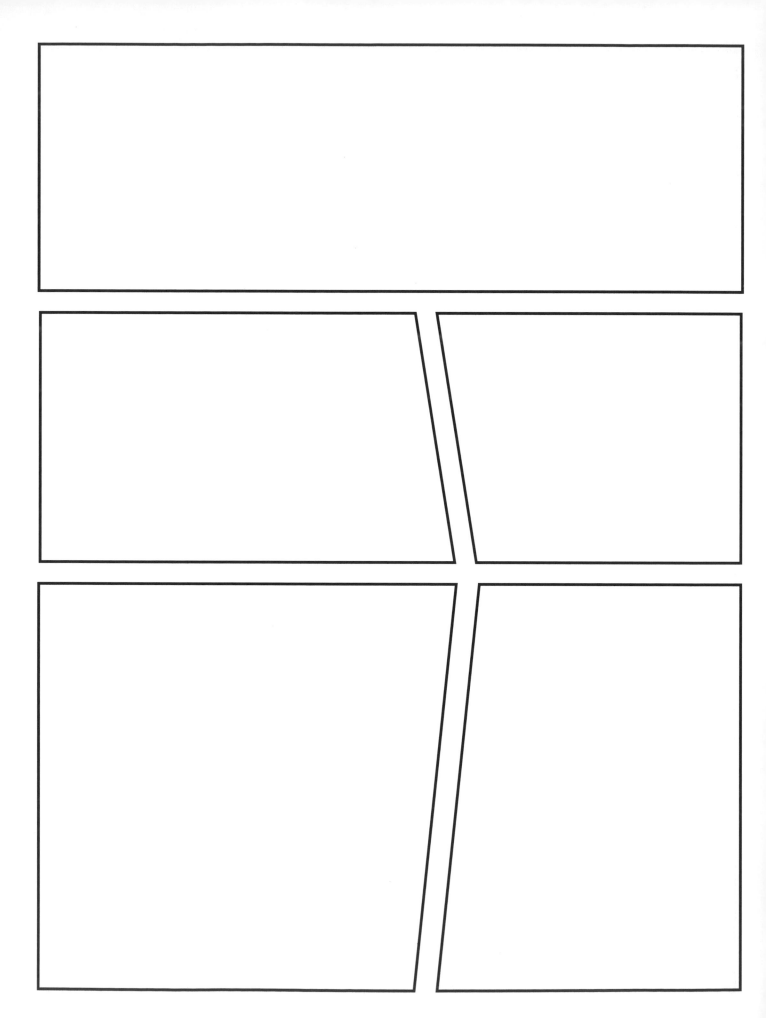

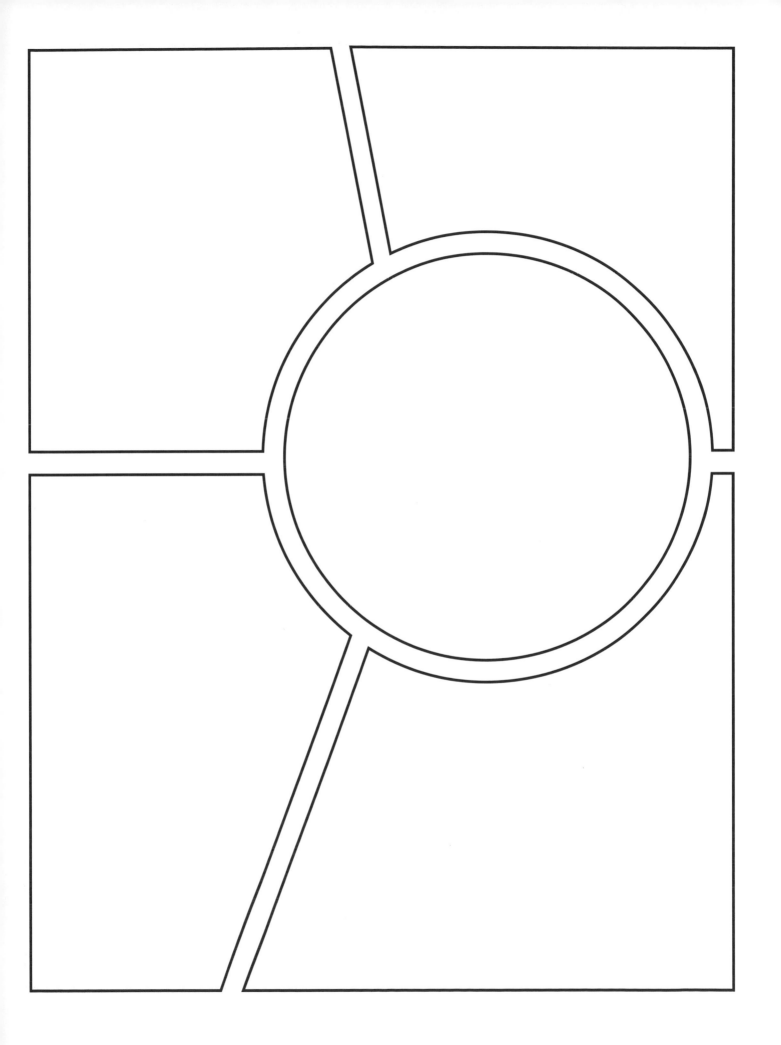

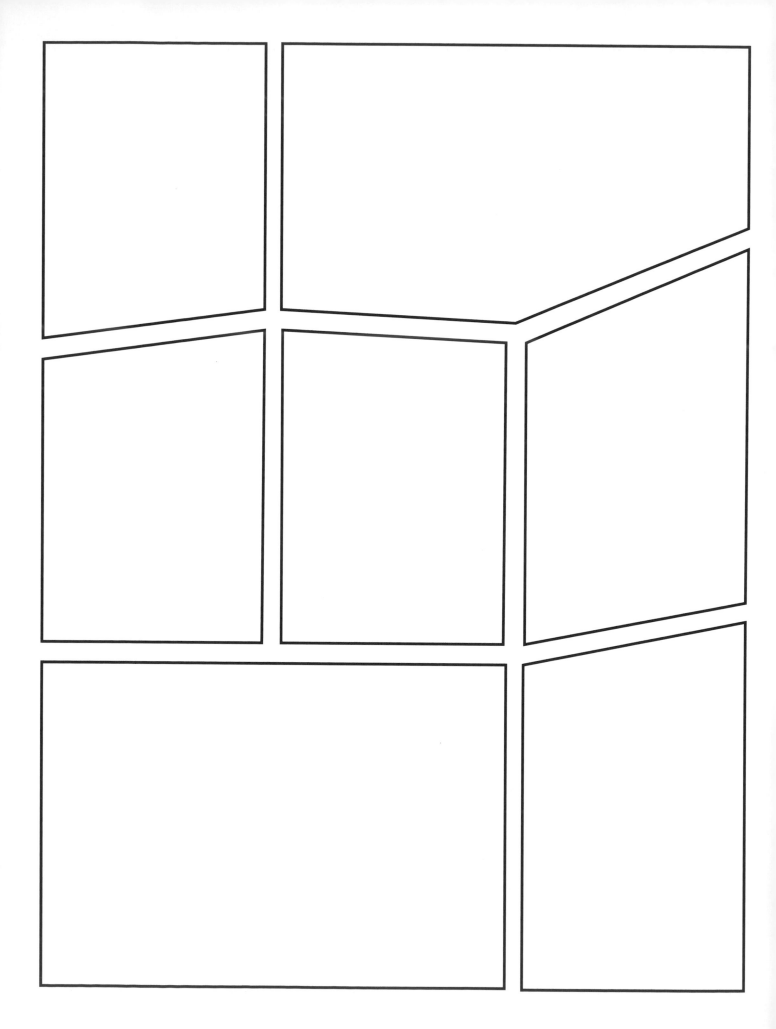

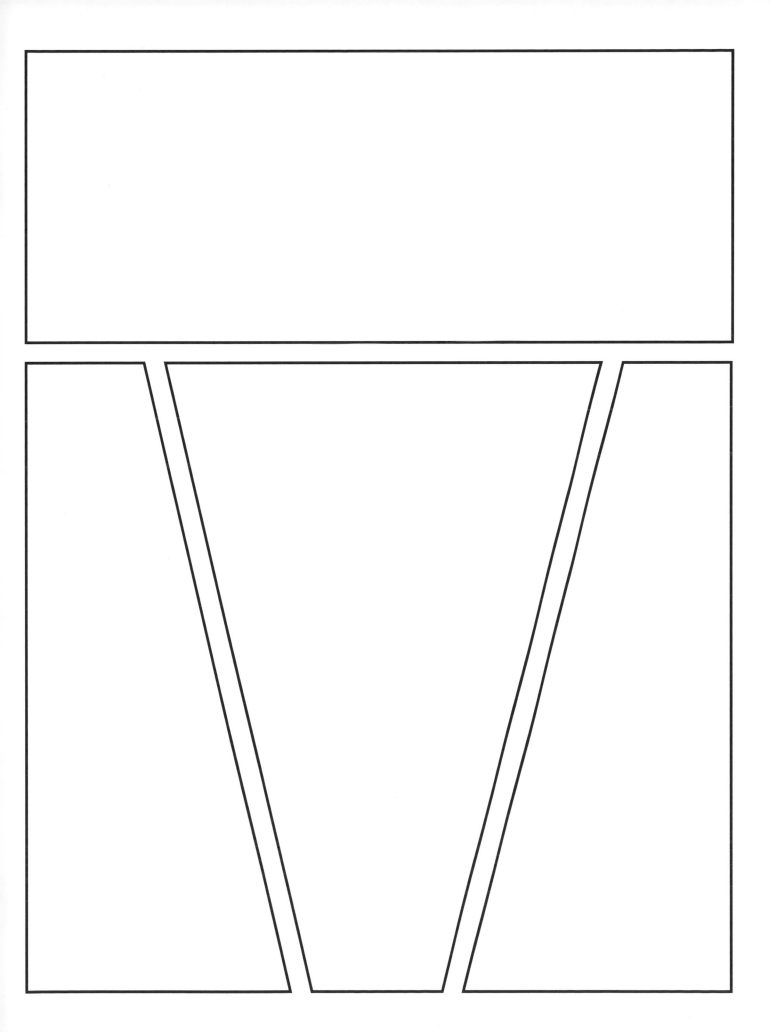

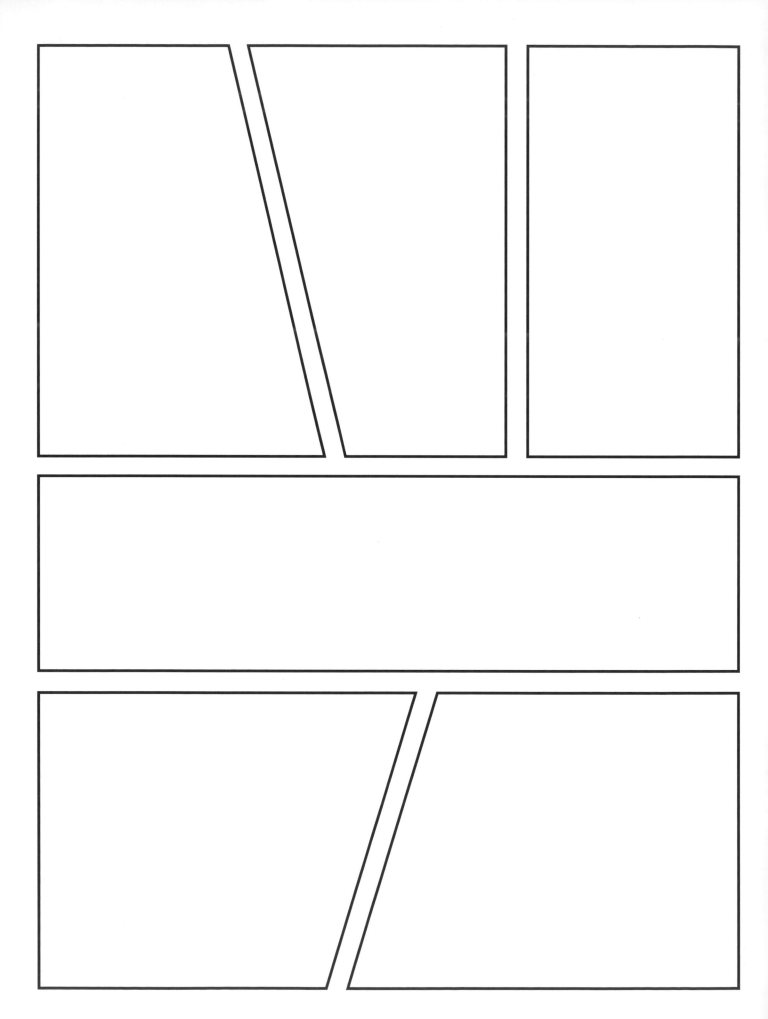

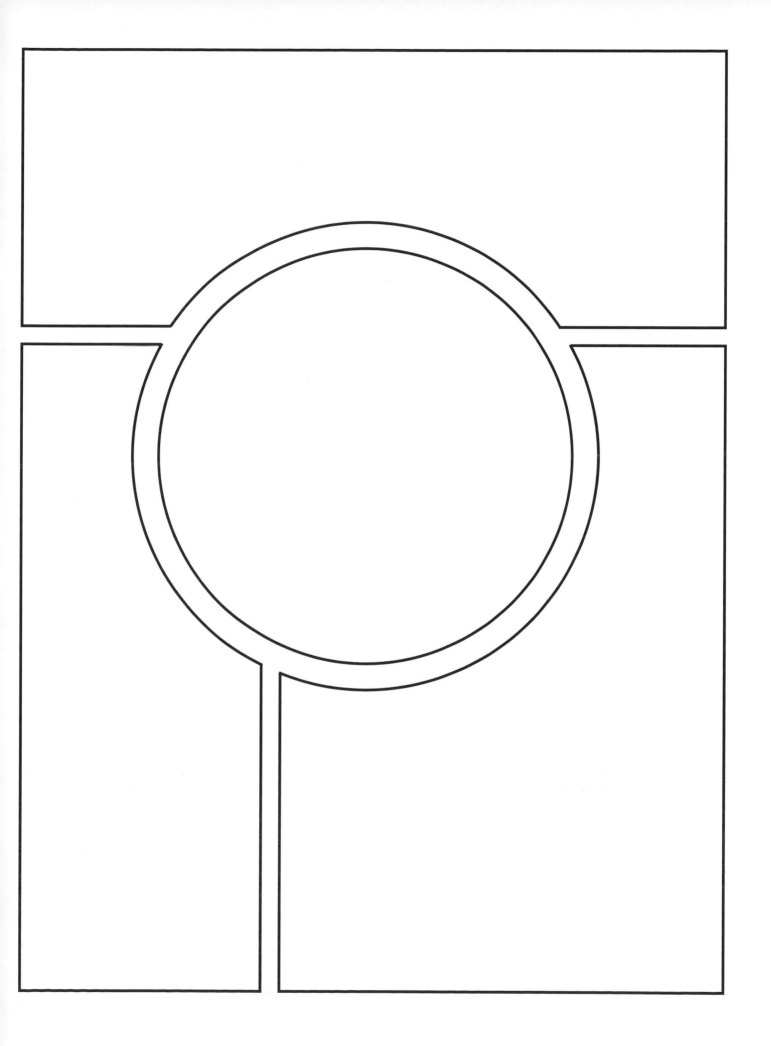

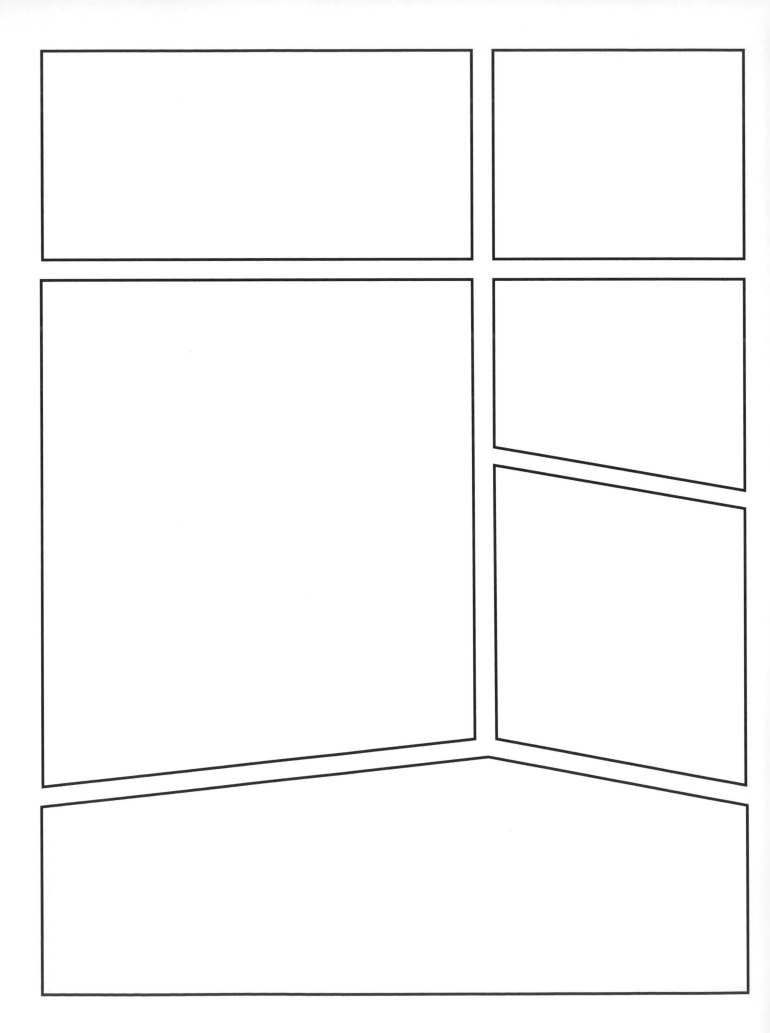

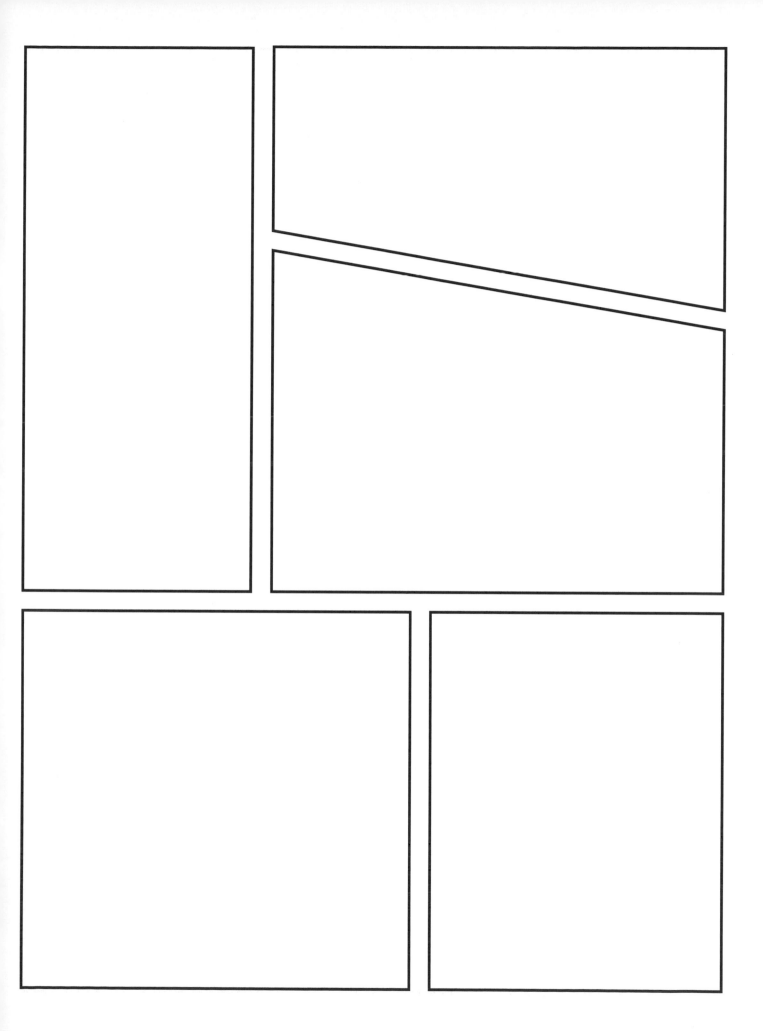

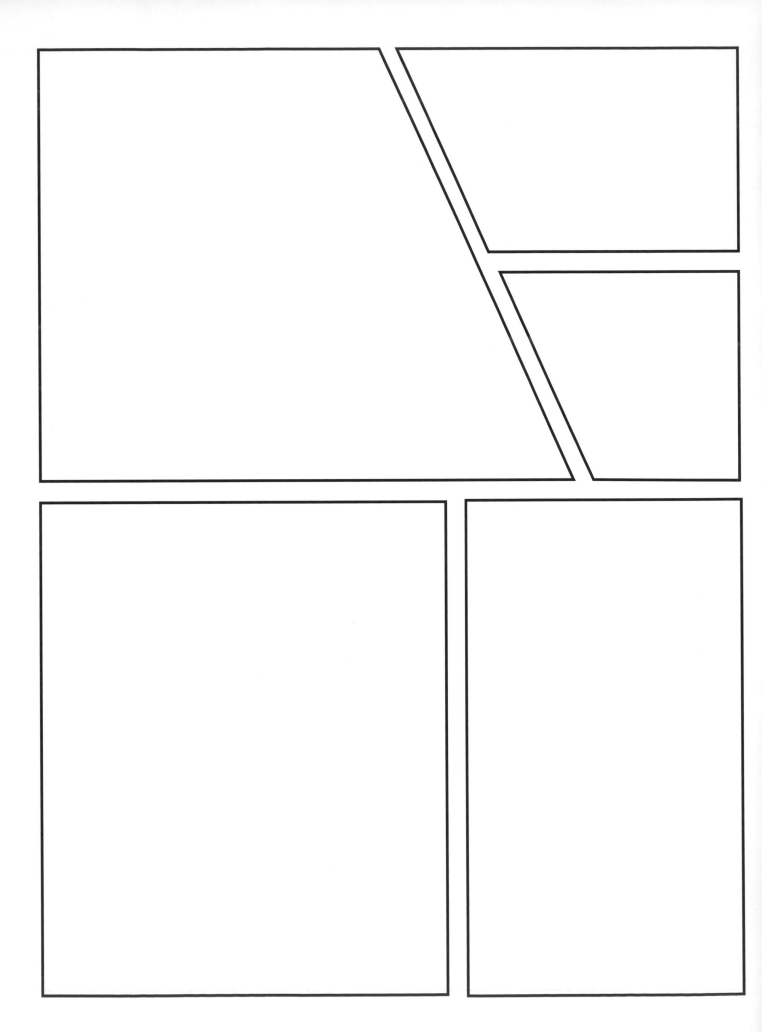

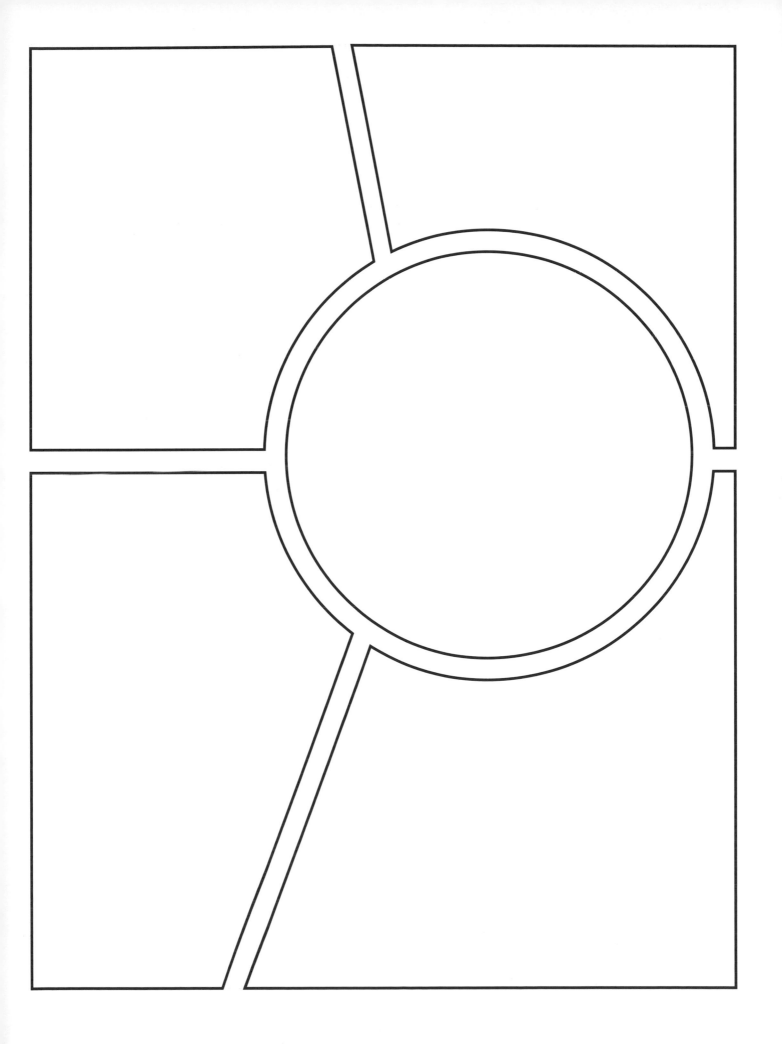

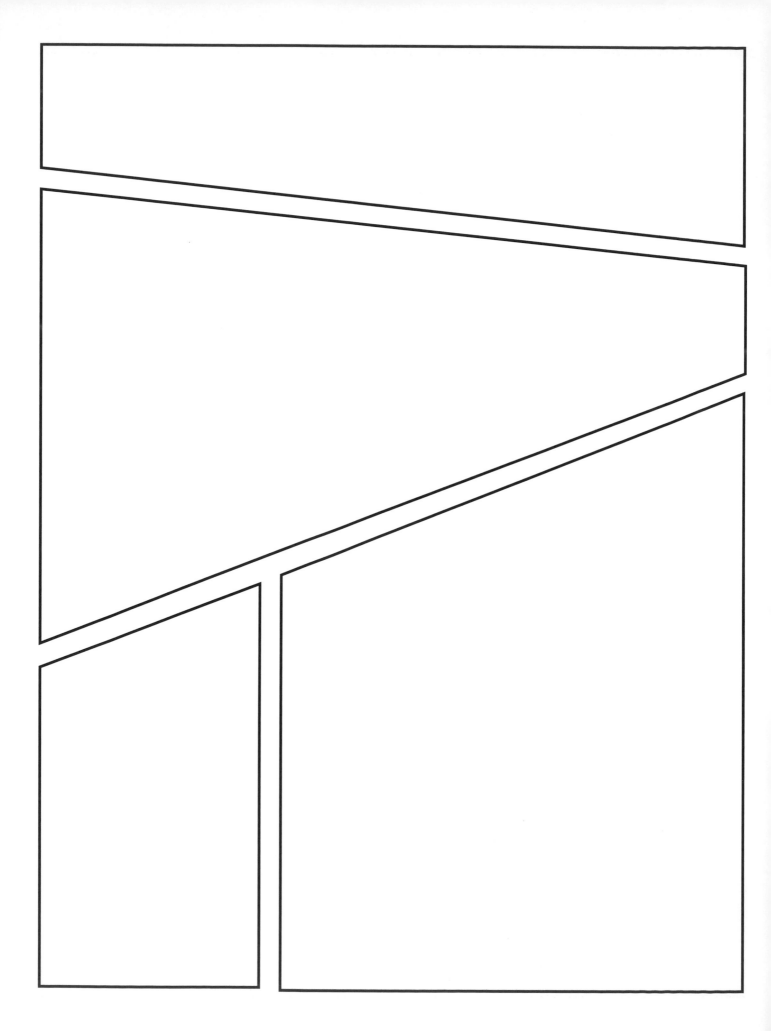

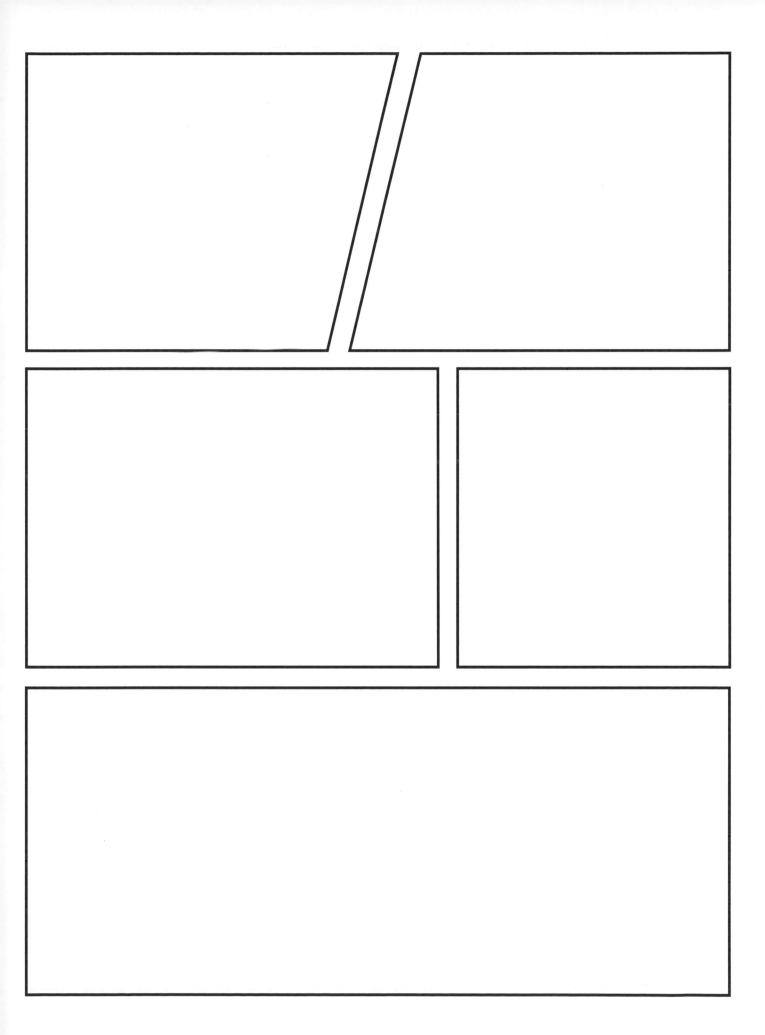

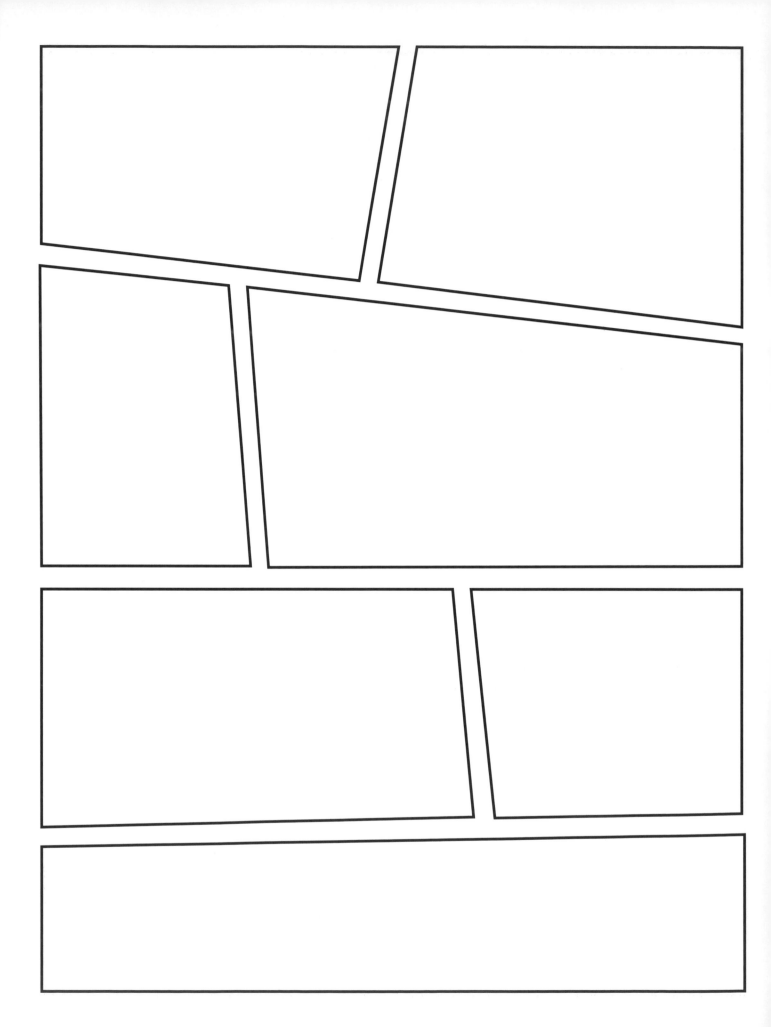

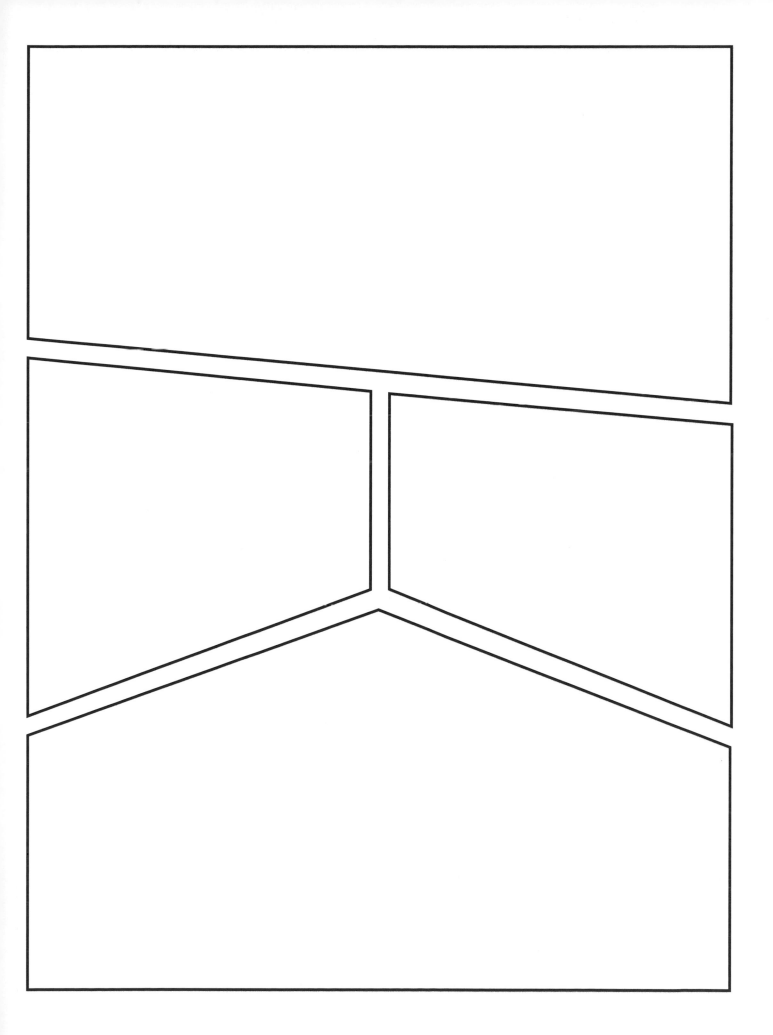

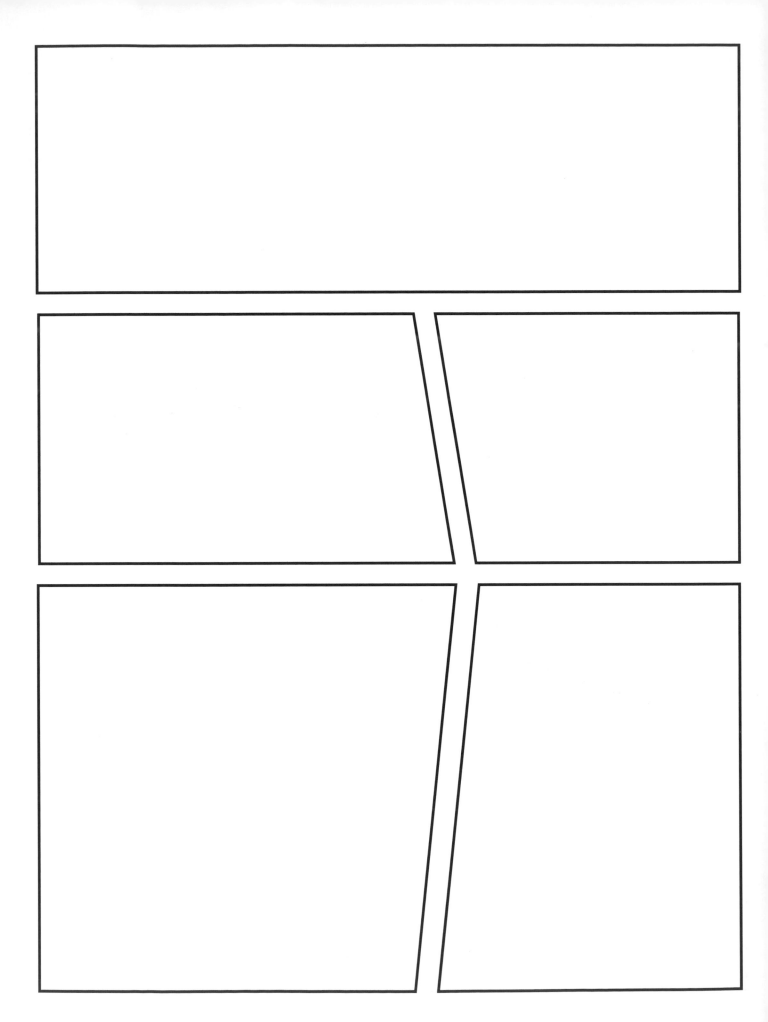

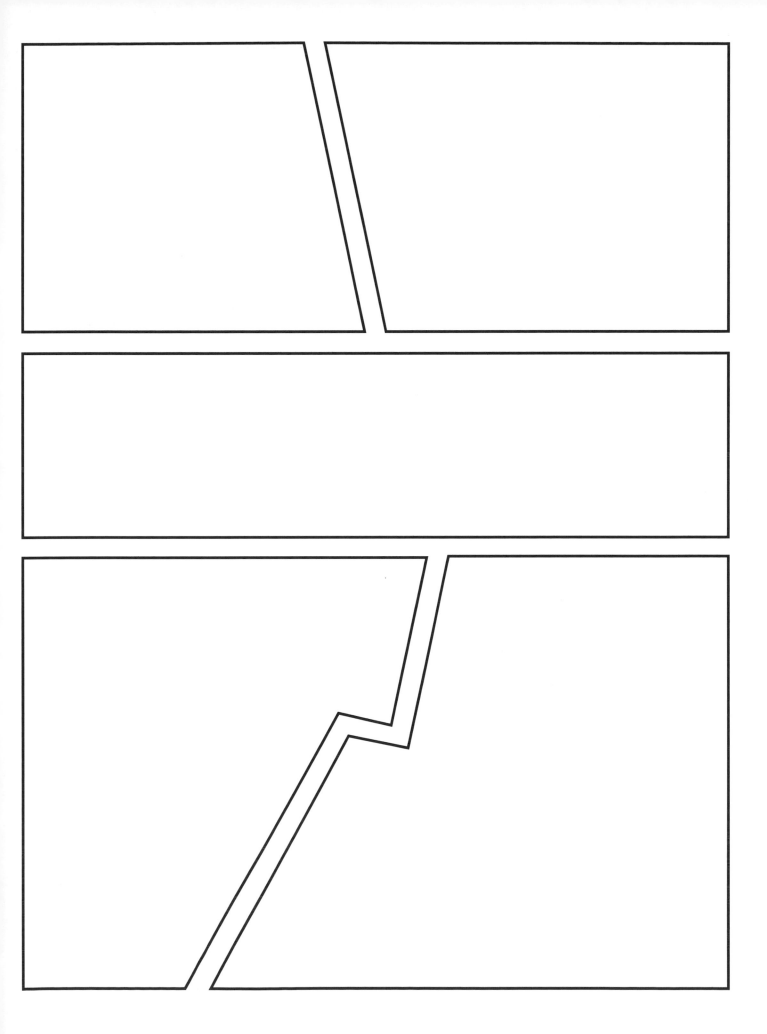

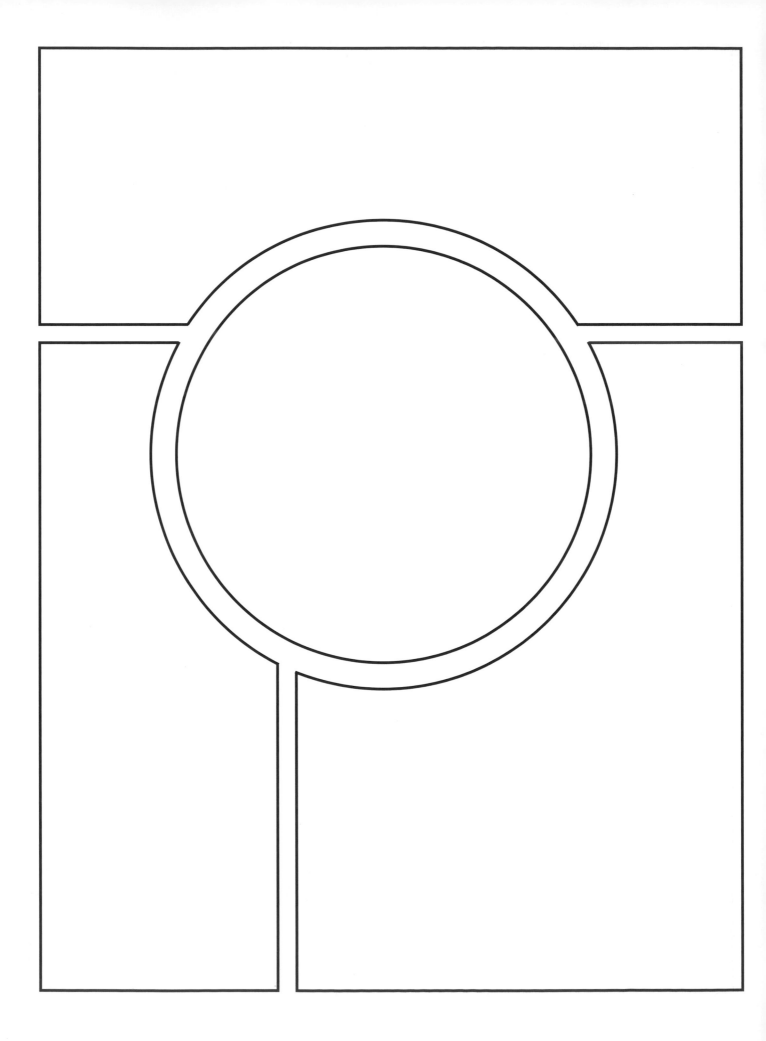

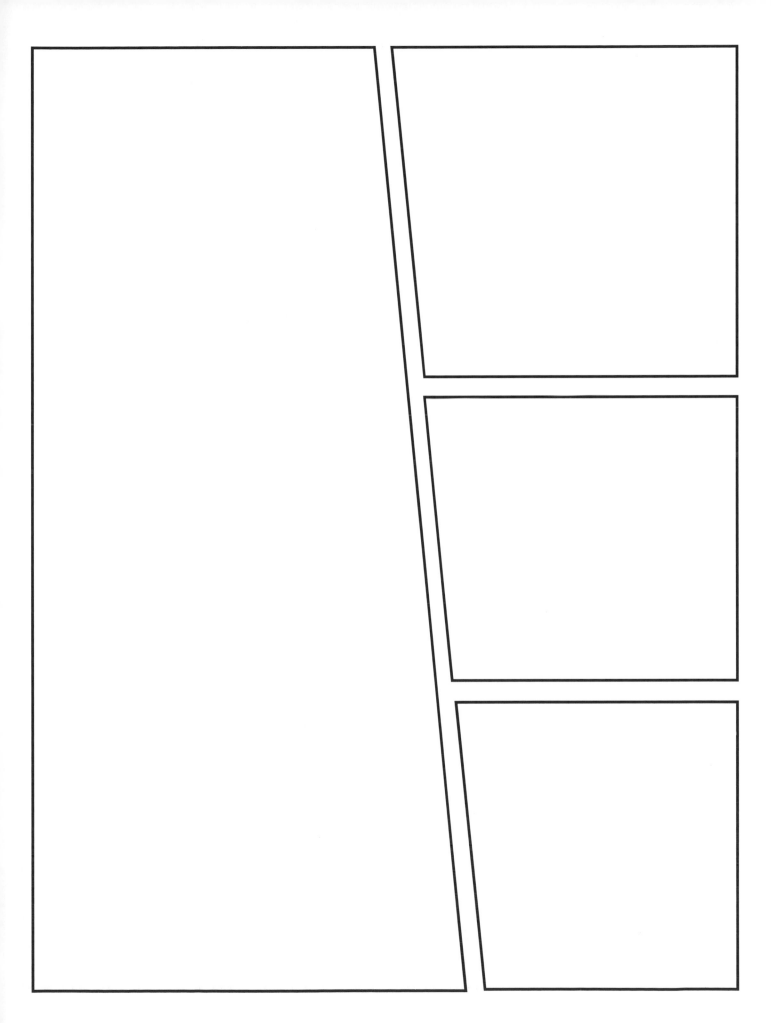

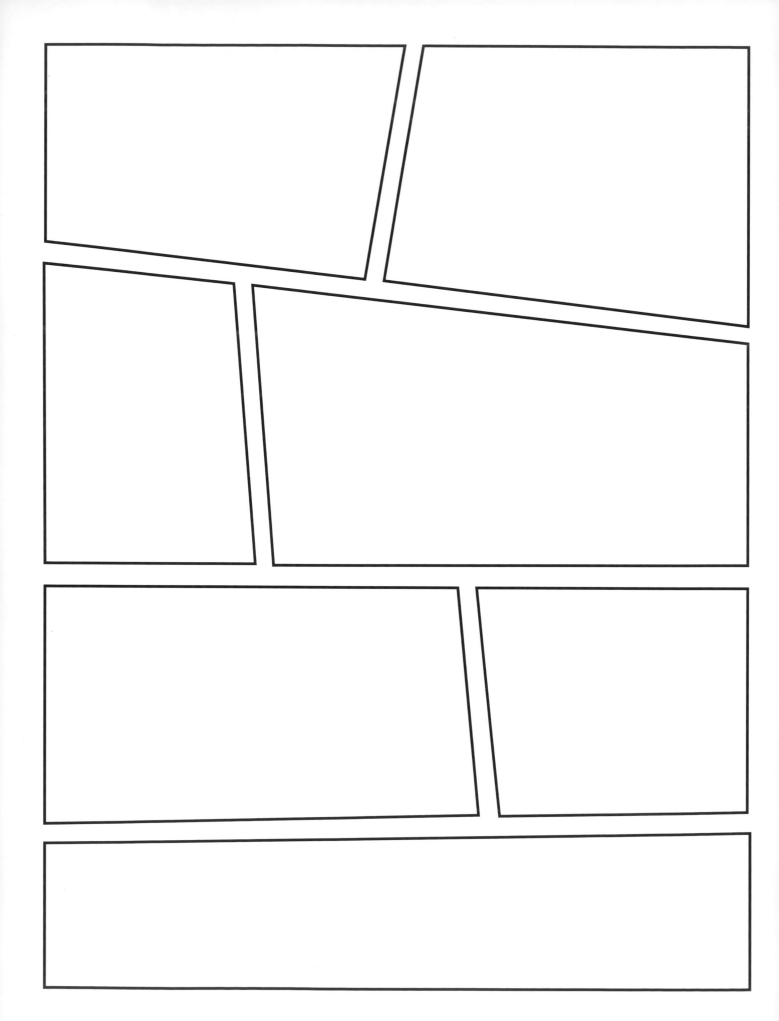

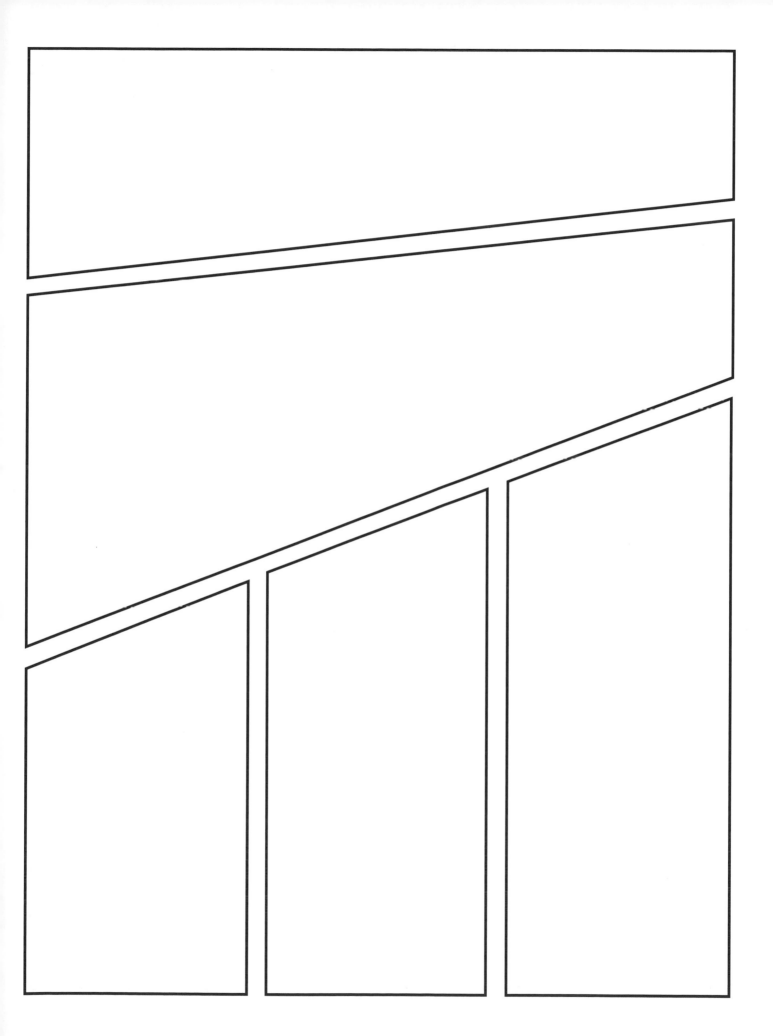

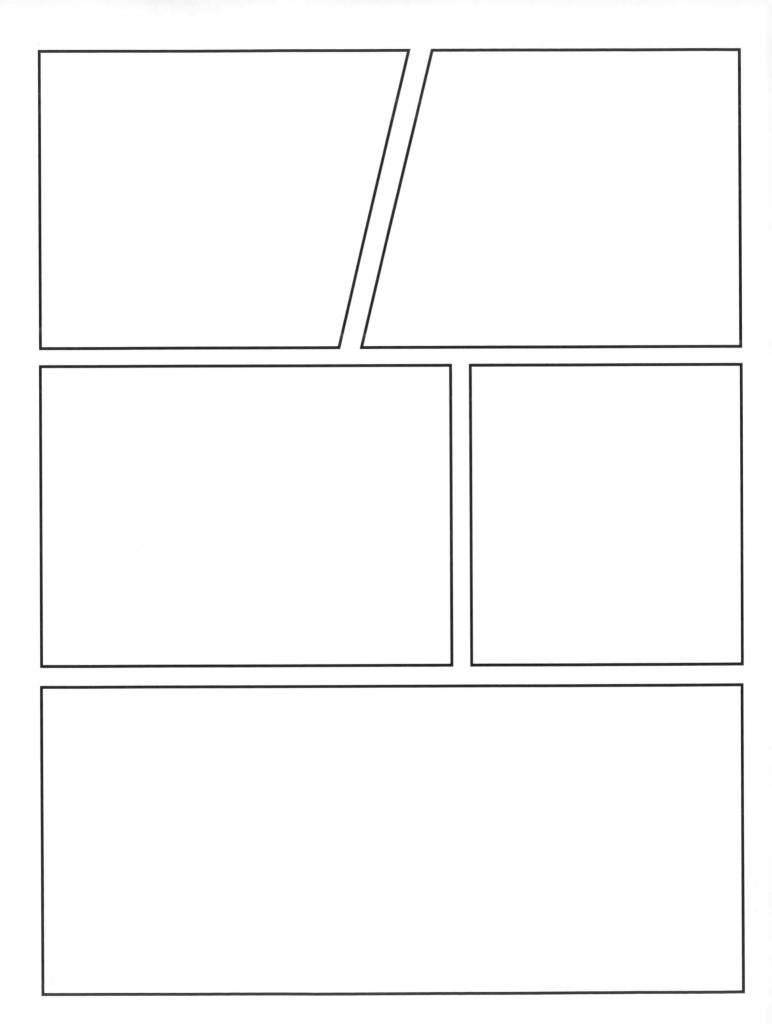

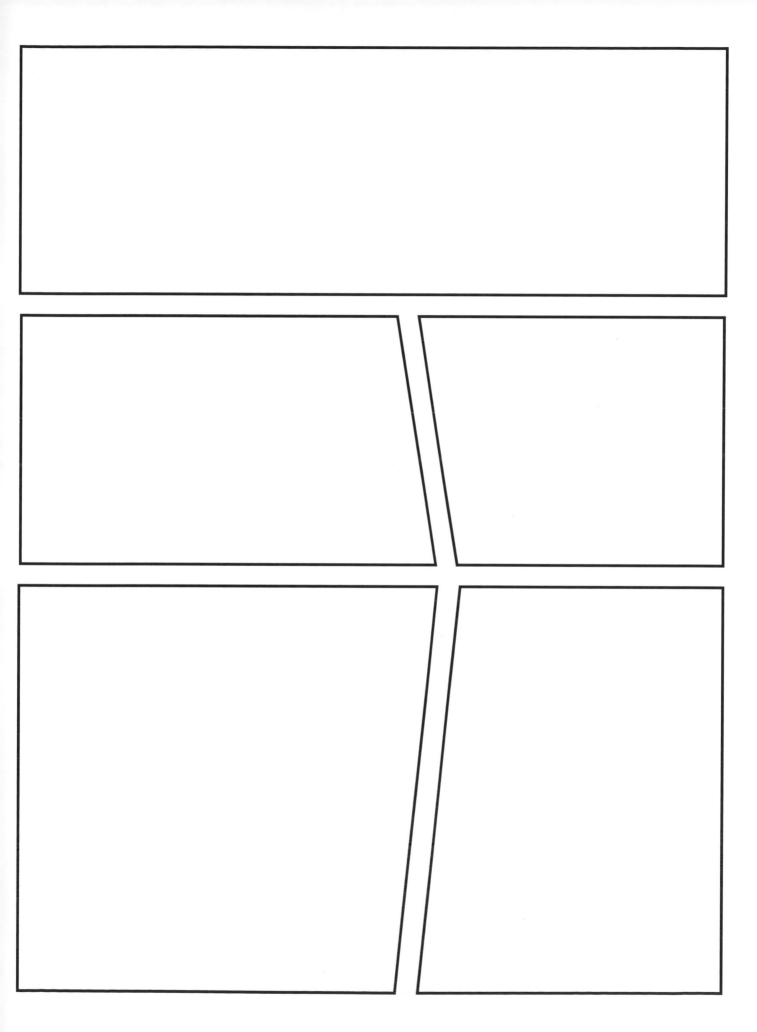

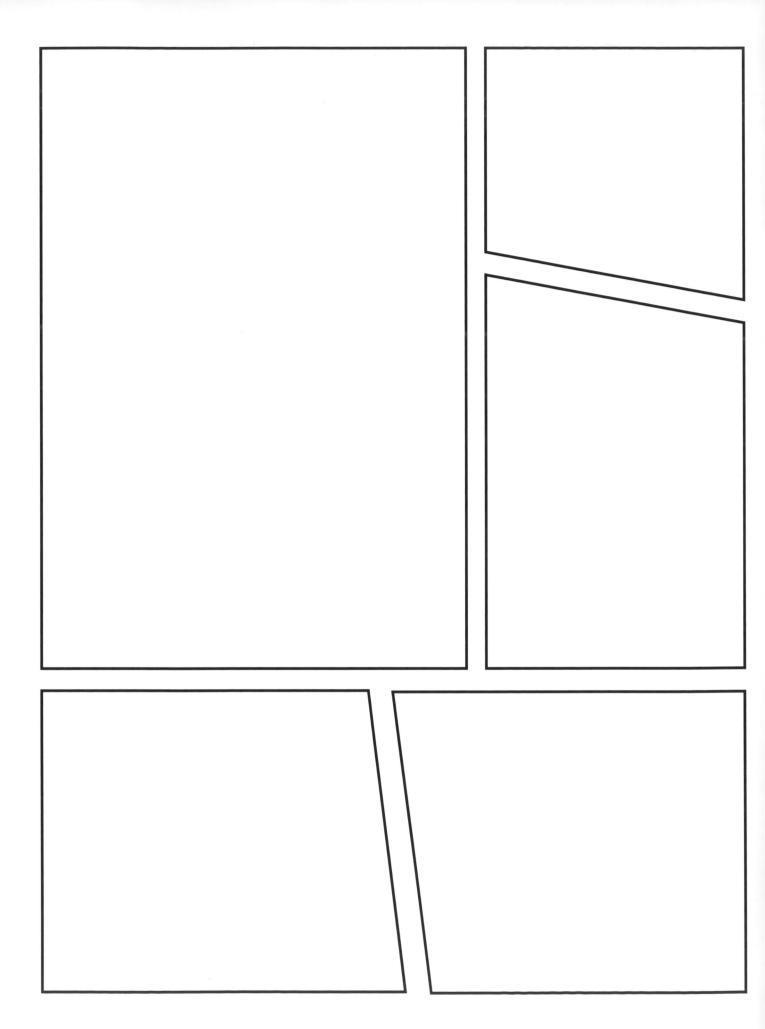

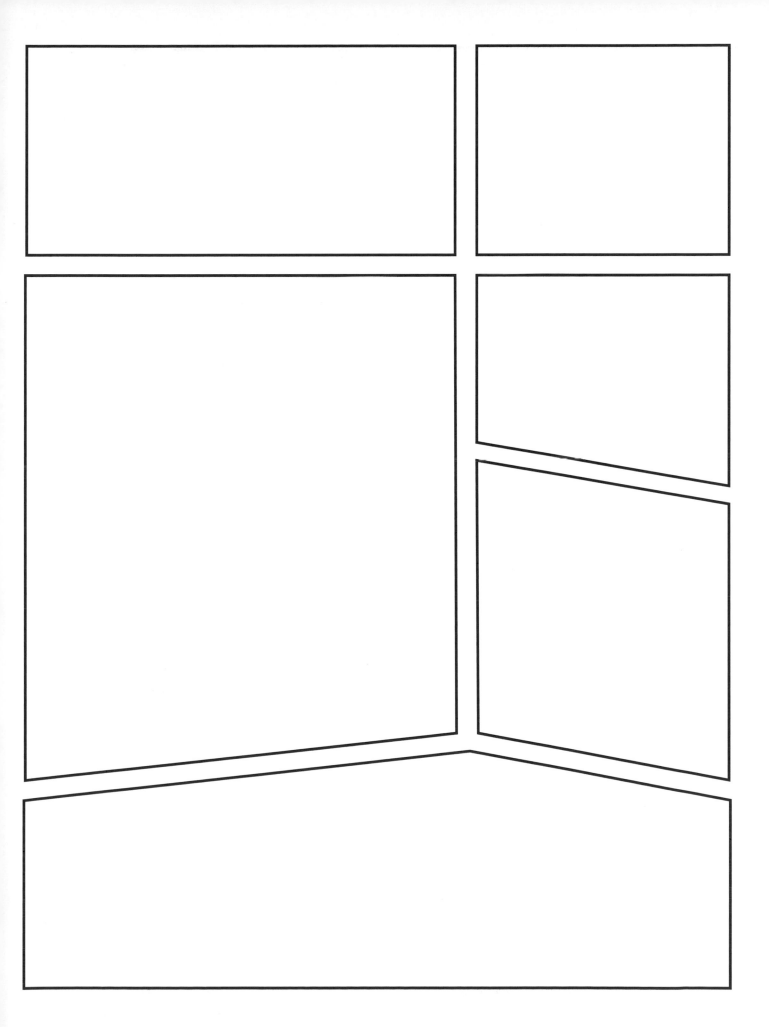

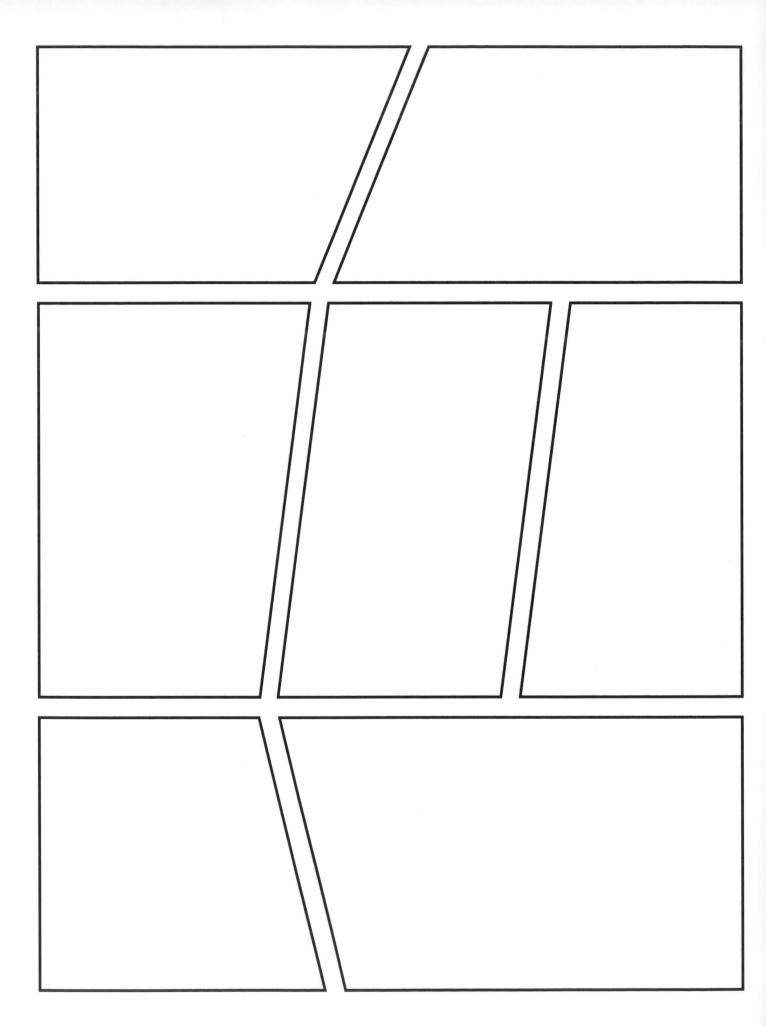

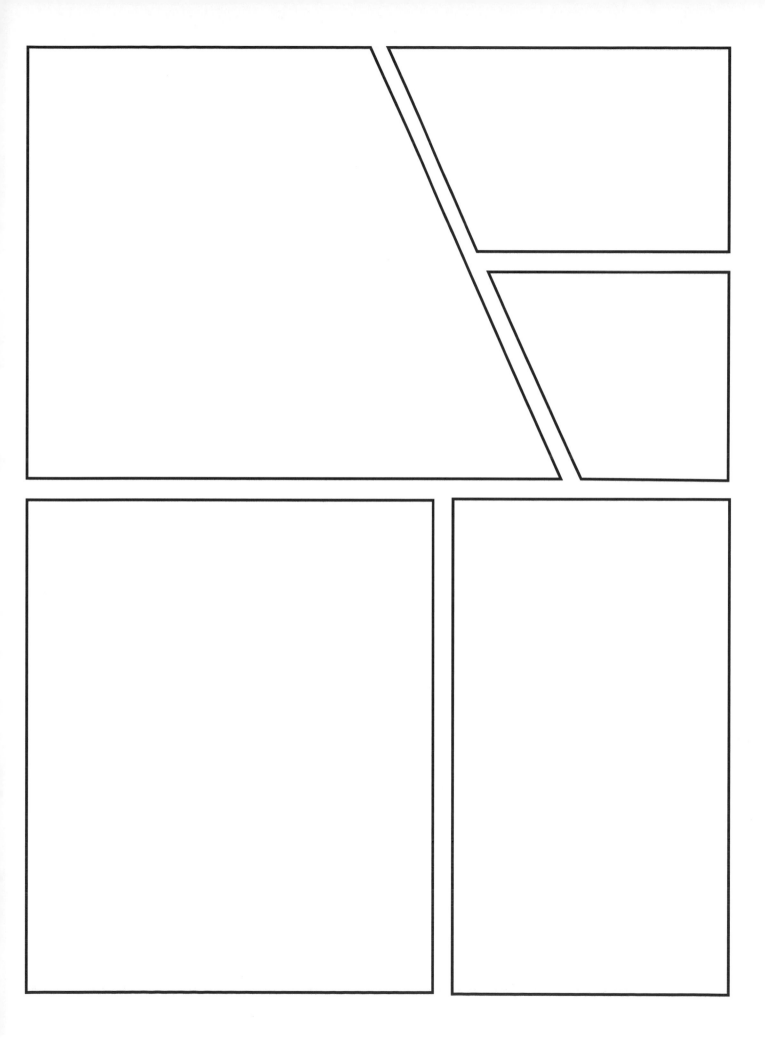

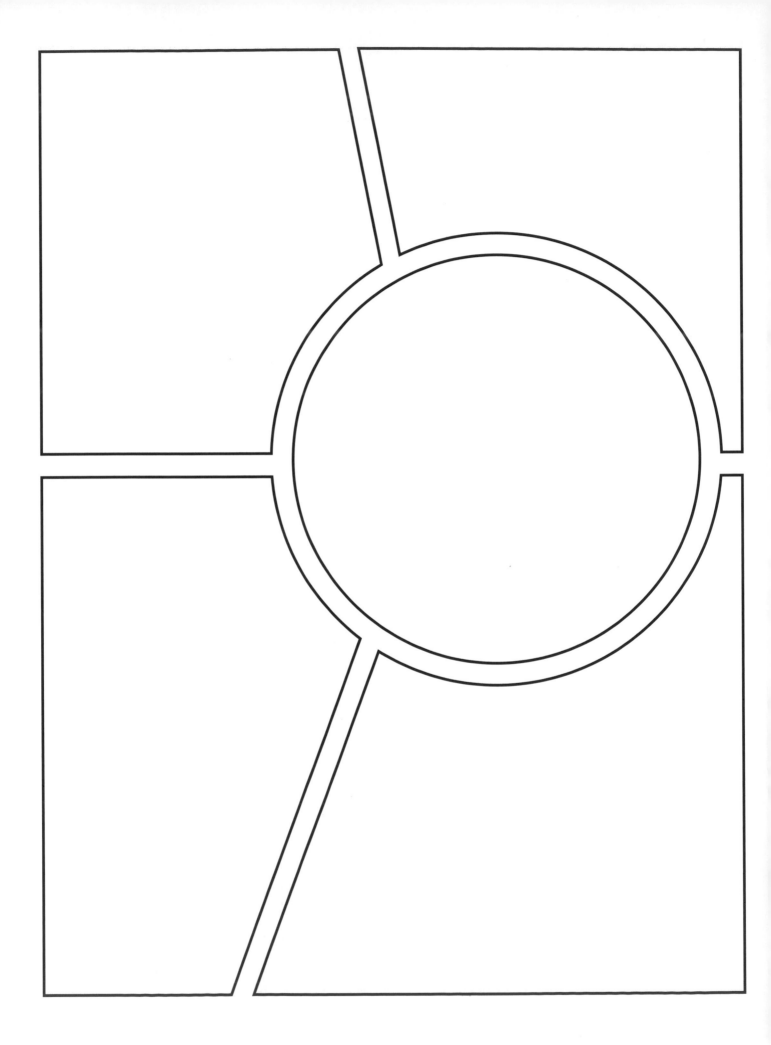

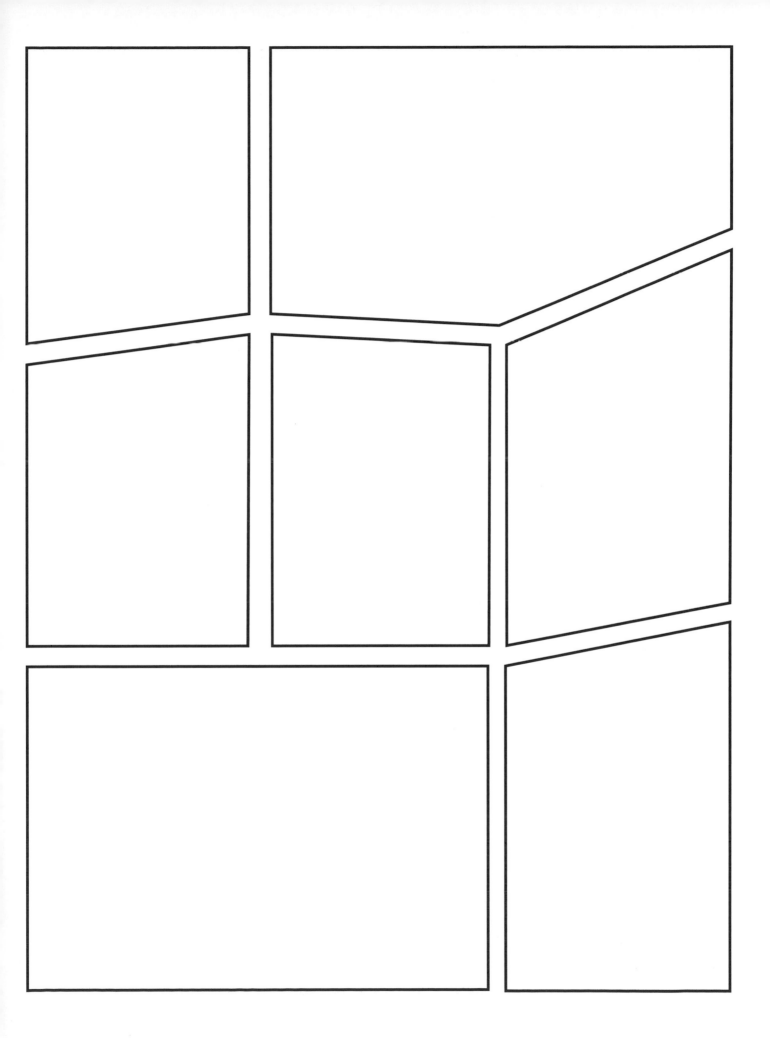

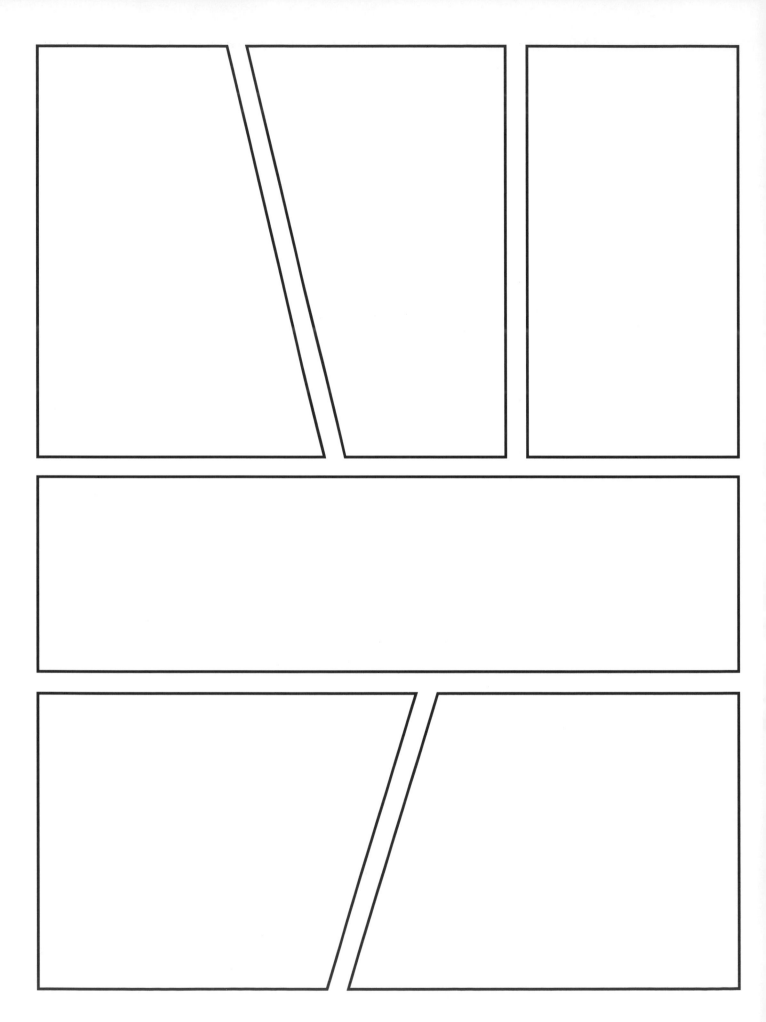

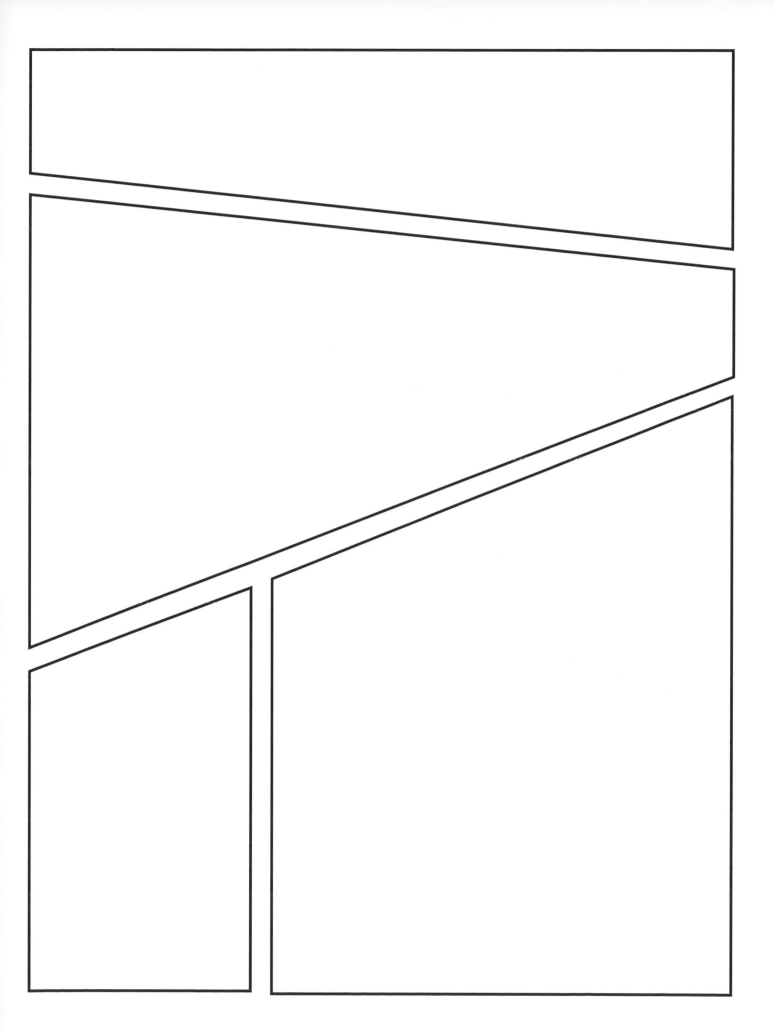

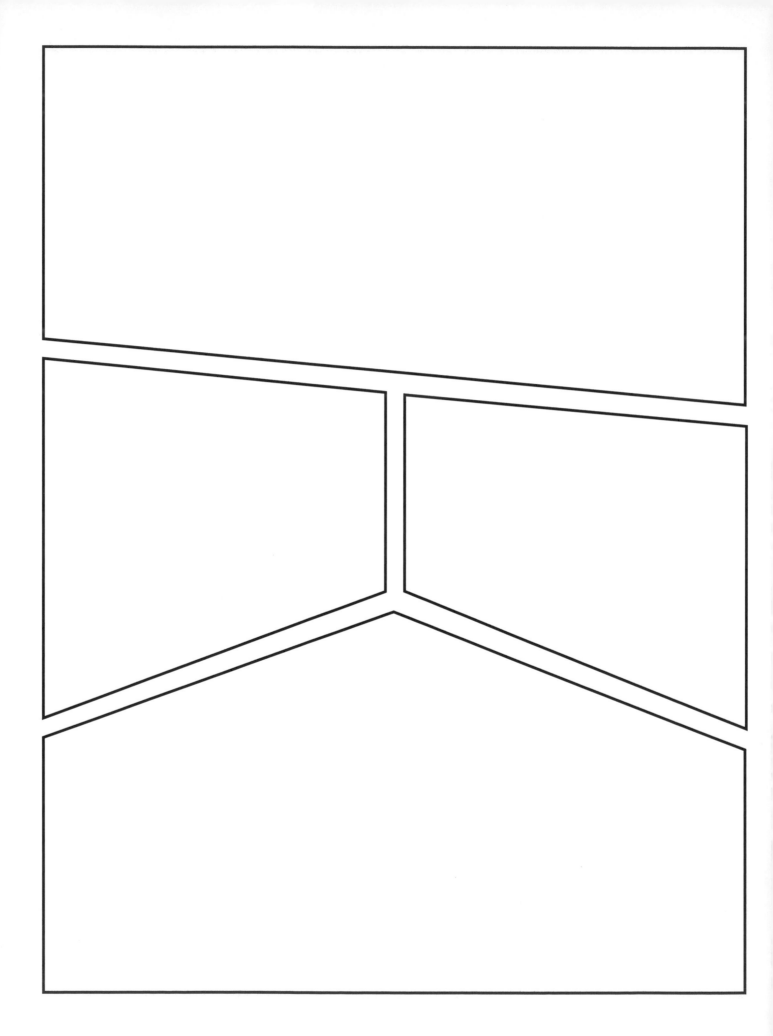

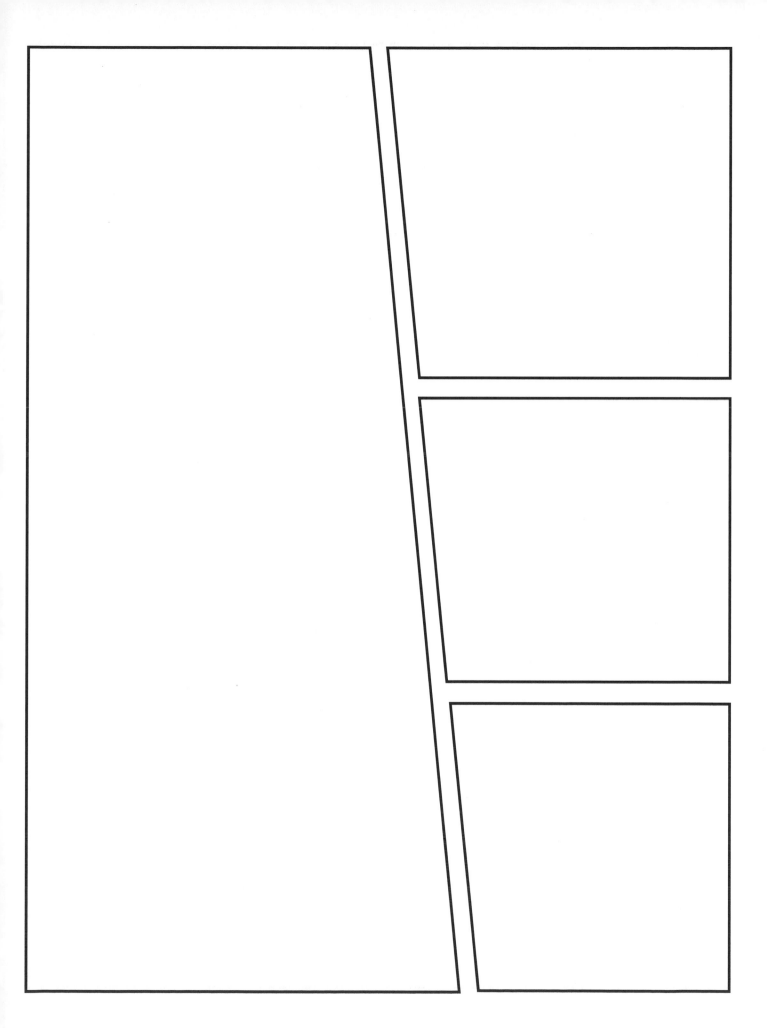

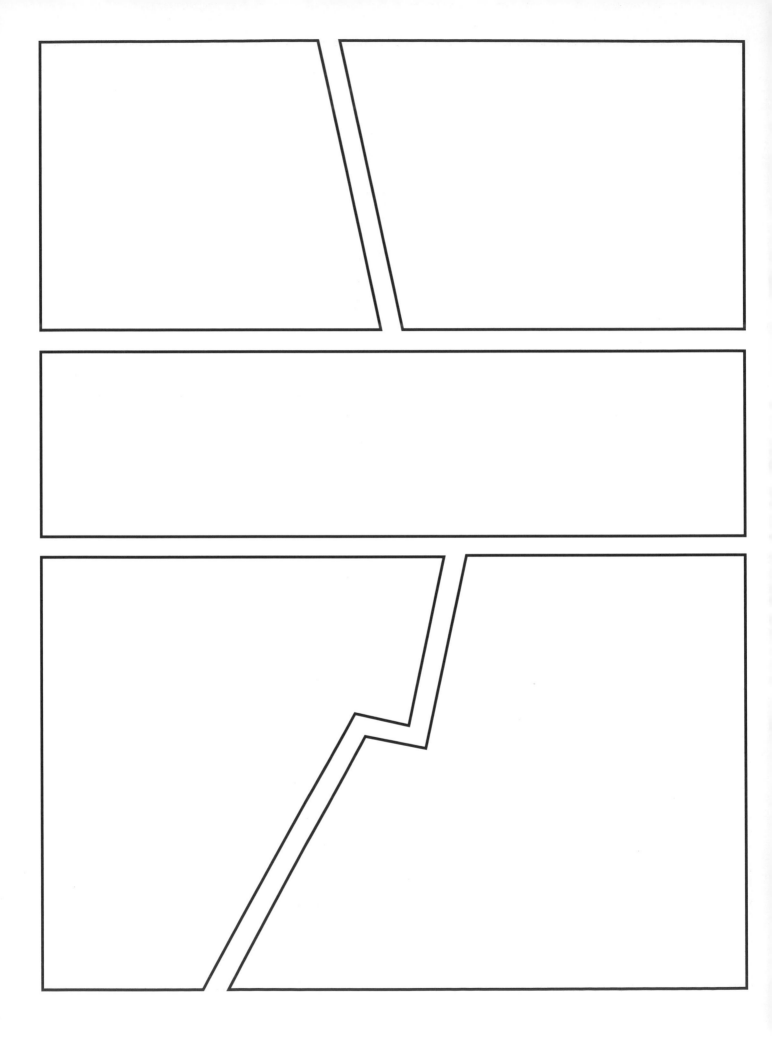

"Books to Span the East and West"

Tuttle Publishing was founded in 1832 in the small New England town of Rutland, Vermont [USA]. Our core values remain as strong today as they were then—to publish best-in-class books which bring people together one page at a time. In 1948, we established a publishing outpost in Japan—and Tuttle is now a leader in publishing English-language books about the arts, languages and cultures of Asia. The world has become a much smaller place today and Asia's economic and cultural influence has grown. Yet the need for meaningful dialogue and information about this diverse region has never been greater. Over the past seven decades, Tuttle has published thousands of books on subjects ranging from martial arts and paper crafts to language learning and literature—and our talented authors, illustrators, designers and photographers have won many prestigious awards. We welcome you to explore the wealth of information available on Asia at **www.tuttlepublishing.com.**